ISAAC BASHEVIS SINGER
AND THE LOWER EAST SIDE

PHOTOGRAPHS BY
BRUCE DAVIDSON

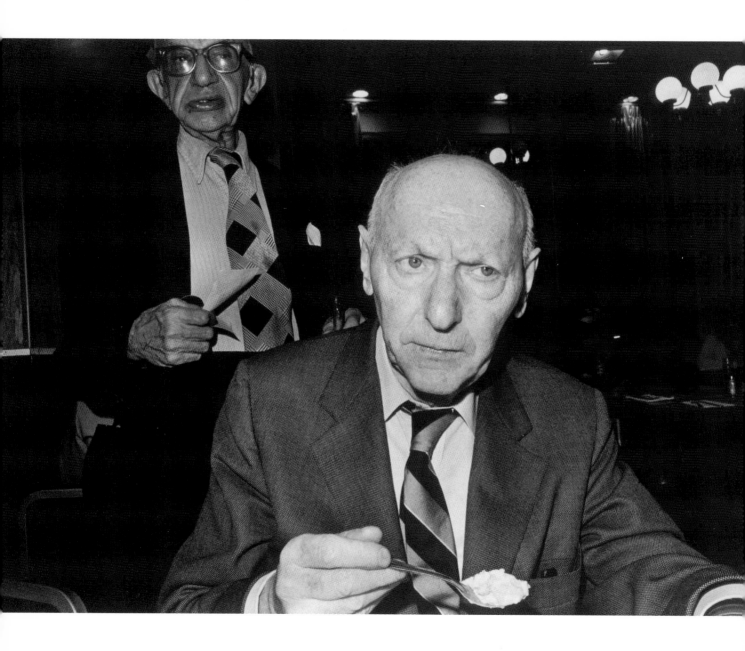

ISAAC BASHEVIS SINGER
AND THE LOWER EAST SIDE

ISAAC BASHEVIS SINGER

BRUCE DAVIDSON

ILAN STAVANS

JILL MEREDITH

GABRIELE WERFFELI

PHOTOGRAPHS BY
BRUCE DAVIDSON

MEAD ART MUSEUM, AMHERST COLLEGE AND UNIVERSITY OF WISCONSIN PRESS 2004

Mead Art Museum
Amherst College
Amherst, Massachusetts 01002-5000
www.amherst.edu/mead

The University of Wisconsin Press
1930 Monroe Street
Madison, Wisconsin 53711-2059
www.wisc.edu/wisconsinpress
3 Henrietta Street
London WC2E 8LU, England

The exhibition and catalogue were made possible by the generous support of the Hall and Kate Peterson Fund and the Richard Templeton (Class of 1931) Photography Fund.

Library of Congress Cataloging-in-Publication Data
Isaac Bashevis Singer and the Lower East Side / Photographs by Bruce Davidson;
contributions by Isaac Bashevis Singer. . . [et al.].
p. cm.
Published in conjunction with the exhibition *Isaac Bashevis Singer and the Lower East Side, Photographs by Bruce Davidson*
organized by the Mead Art Museum, Amherst College, 7 September – 24 October 2004.
ISBN: 0-299-20624-6 (pbk. : alk. paper)
1. Davidson, Bruce, 1933—. 2. Singer, Isaac Bashevis, 1904-91. 3. Photography, Artistic.
I. Singer, Isaac Bashevis, 1904-91. II. Mead Art Museum (Amherst College). III. Title.
TR654.D362 2004
779'.997471—dc22 2004017385

Designed by Donna M. Abelli
Set in Arial Narrow and New York
Printed and bound in the United States of America by Tiger Press in Northampton, Massachusetts

TABLE OF CONTENTS

"ISAAC SINGER ALLOWED ME

TO TOUCH SOMETHING I HAD

NEVER BEEN ABLE TO

REACH BEFORE."

— BRUCE DAVIDSON

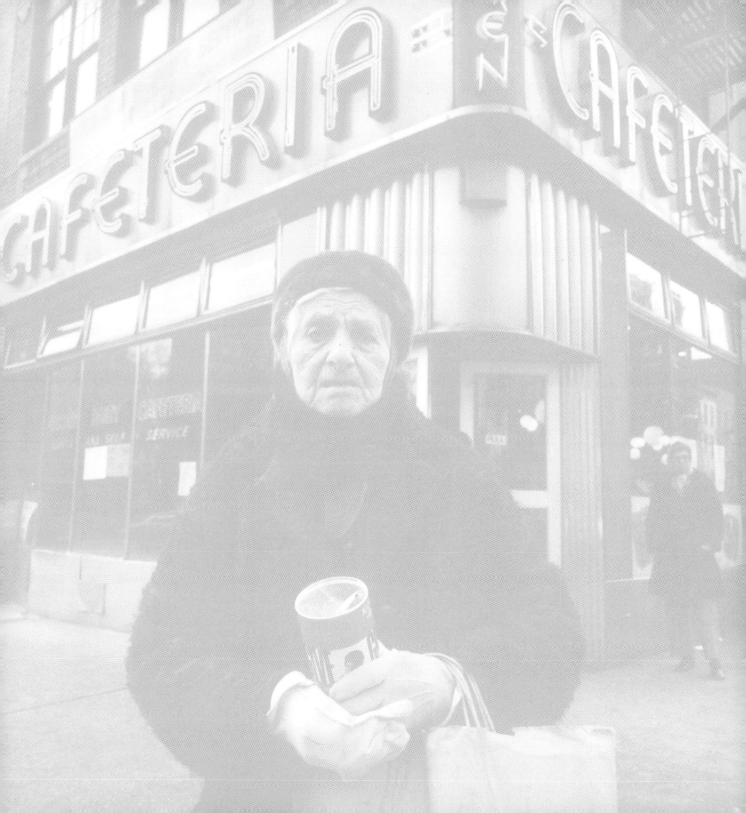

BRUCE DAVIDSON'S LOWER EAST SIDE

JILL MEREDITH

Bruce Davidson disclosed that he was back photographing on the Lower East Side. This time, May of 2004, he was making pictures from behind the deli counter at Katz's. At first they were reticent to give him access. "I told them I had photographed in delicate situations before such as during a liver transplant. And then they observed that they transplant a lot of liver here too!" Camouflaged in a counterman's white cap, he could unobtrusively document the food preparation and patrons: "When I wear the white cap, no one notices my camera." Proud of the gig, he remarked on the amazing ethnic mix at the Lower East Side institution with its diversity of contemporary New Yorkers and international tourists: "A good pastrami sandwich could bring peace to the world!"

Davidson, like many documentarians, immerses himself in a social theme defined by a specific locale—Montmartre, East 100th Street in Harlem, Brooklyn, the Deep South —and upon completion of the project, moves on to another locale. During the years 1966-68, when he chronicled life on what was called the "worst block in the city," Davidson photographed East 100th Street each day with his large view camera. "Like the TV repairman or the organ grinder, I appeared and became part of the street life." Yet uncharacteristically, Davidson has returned repeatedly to the Lower East Side of New York for nearly fifty years to produce images that resonate with the convergence of past and present, Old World and New World, youth and old age, remembrance and timelessness. Although his work on the Lower East Side, beginning in 1957, was not planned as a monographic project, in hindsight it is a body of work that reflects his roots and his life's journey both as a photographer and as a Jewish man.

Educated at the Rochester Institute of Technology and Yale University School of Design in the early fifties, Davidson made frequent forays into the streets of Chicago, New York, and Paris to photograph. It was in Paris that he "found a feeling with Mme. Fauchet [his elderly subject in Montmartre] that touched the past." And where, too, he first met Henri Cartier-Bresson, who encouraged his early work. Davidson joined

him in a brief walk through Paris where he had the opportunity to observe: "the streets became his photographs. A young couple embraced, a fat man walked, and a child skipped. Cartier-Bresson paused and held his Leica smoothly to his eye." Although picking up short term assignments and aspiring to become a *Life* photographer, a much desired staff position did not materialize and Davidson returned to New York and to the streets. There, he strove to emulate W. Eugene Smith in conveying emotion and the human condition.

An émigré from the Midwest and an assimilated second generation Jew, Davidson went to the Lower East Side, where Jewish immigrants from Eastern Europe had settled in the late 1800s and early 1900s. "I felt free in the teeming vitality of the tenement streets." Like the immigrants from the Old World, Davidson was ready to begin a new life. In the winter of 1958 he joined Magnum Photos, the cooperative photographic agency co-founded by Cartier-Bresson and other photojournalists in 1947. And when Cartier-Bresson visited New York on assignment in 1958, Davidson took him on the bus to visit the Lower East Side — his world. As they had done in Paris, once on the street they went their separate ways to photograph. "As I walked, I took photographs of a fish peddler holding a fish, a plucked chicken hanging in a window of a kosher butcher shop, and children flying their kites down the tenement street."

The tenement streets of the Lower East Side sixty years earlier were the slums chronicled by social reforming journalist and photographer Jacob Riis in *How the Other Half Lives* (1890). Riis' factual style, as well as Lewis Hine's warmer, more empathetic and individualistic approach to early twentieth-century Ellis Island immigrants, inspired Davidson in some of the earliest work he did there, in 1957, as well as his epic East 100th Street project. Images from this period, including "Jewish schoolboy and girl with doll" [Plate 1] and "Butcher and baby carriage" [Plate 2], display Davidson's concern for being the unobtrusive observer in the manner of Cartier-Bresson, using his Leica similarly to document "the decisive moment" that defines the character and

circumstances of his subjects. His interest in children, whose activities mirror the adult world outside their play space, relates not to the images of working drudges by Hine, but rather to the socially conscious photographs of Helen Levitt, Morris Engel, and Aaron Siskind—all Jewish photographers who recorded New York street life in the 1930s and 1940s.

"Jewish schoolboy and girl with doll," in particular, recalls the prewar New York City children depicted by Helen Levitt, one of a handful of Jewish photographers who worked on the Lower East Side. Like Levitt, Davidson caught them in a moment of everyday activity within their immediate community as defined by a limited view of a street, steps, and urban debris. Davidson's photograph of a Jewish school boy, presumably en route to school, who passes and turns to look at a girl huddled over her scruffy doll in its milk crate cradle contrasts the idealized world of childhood play with the implied distinctions of adult men and women that they are yet to become. While in Levitt's photographs the ethnic milieu may be unspecified, Davidson's boy wears a *yarmulke*. This image reflects not only the more generic child/adult dichotomy and urban poverty, but also a truth about this observant Jewish neighborhood. Embedded in this contemporary image is the allusion to the Old World tradition of the *yeshiva bucher*, who pores over the holy books and discusses the commentaries, while his wife raises their children and runs the family store.

At this point was there any direct relationship between Davidson's ethnicity and his photography, rendering him more empathetic to Jewish subjects? Davidson had experienced the adolescent ritual of becoming a Bar Mitzvah. He grew up in an assimilated non-observant middle class family, where forgetting (it was largely memorization) a few lines of his Torah portion went without comment. While he may have felt some intuitive connection with this young boy heading off to school, any pull to discover or recover his Jewish past was nascent at most. Nevertheless, although more American than Jewish, this dual identity still rendered him an outsider as Jews

were always outsiders in the dominant culture. And as an outsider, he was an effective observer.

Davidson's early explorations of the Lower East Side were close to home since he lived and worked nearby, in Greenwich Village, until the late 1960s. In 1965, he met and photographed the Yiddish writer, Isaac Bashevis Singer, while on a magazine assignment. In the late 1960s, after his marriage to Emily Haas, Davidson needed more residential and working space and found an apartment on West 86th Street. Coincidentally, it was the same building where Singer lived. They struck up an acquaintance from chance meetings in the elevator and Davidson began to read Singer's novels and stories in translation, which he describes as providing "a sense of my own lost heritage." Davidson had already embarked on a side career in documentary filmmaking and received a second American Film Institute grant, in 1972, to profile an American writer for public television. He chose Isaac Bashevis Singer.

Although he wished to work in fiction, the grant was for a documentary. So to disguise the fact that he was making fiction, Davidson wrote a script based on Singer's story "The Beard," in which Singer was both the subject of the documentary as well as an actor in his own story. The story, set in a cafeteria and in the narrator's apartment, was filmed in nine days at Singer's apartment and his haunt, the Garden Cafeteria. In preparation, Singer took Davidson to this literary cafeteria, near the office of *The Jewish Daily Forward*, where he often sat, observed, and wrote. The completed film, *Isaac Singer's Nightmare and Mrs. Pupko's Beard*, was distributed for public television and won first prize for fiction at the American Film Festival in 1973.

Singer's work, life, and conversations inspired Davidson's return to the Lower East Side to document the Garden Cafeteria and its patrons in a photo essay. These compelling black and white images [Plates 5–17] with their original preface by Isaac Bashevis Singer [Plates 3, 4] appear together here for the first time, although a selection

14

were published in the October 15, 1973 issue of *New York Magazine*, along with Davidson's interviews with his subjects.

In this project, Davidson combined the humanistic concerns and visual approach he employed in *East 100th Street* with the familiarity he had derived from his involvement with Singer and acceptance of his own ethnicity. "I needed to return to what I knew. I went back among the old people who sat in the cafeteria that Singer had shown me." Singer had introduced Davidson to his veritable second home at 165 East Broadway, where he ate and discussed literature and life's riddles over "mountains of rice pudding." But it was Davidson who became interested in the history of the cafeteria and what it meant in contemporary times. "So every day, for weeks, I went to the Garden, took a check, got some coffee and sat down with people at the small tables along the wall."

The Cafeteria photographs are environmental portraits, providing a sense of place that juxtaposes the private sadness and impoverished misery of contemporary life with memory of a distant past of hope and promise. In "Two men sitting in front of a mural," [Plate 6] Davidson reveals the contrast between past and present with stark clarity. Their bowed heads, one deep in thought and one regarding the camera, frame the painted mural (ca. 1940) depicting an old Lower East Side street scene with neighborhood Jews purchasing and reading *The Jewish Daily Forward*. Davidson photographed other customers seated at this table under the mural, including Florence Strauss, a seller of *bialys*, and her son Martin Lockit [Plate 15]. The visual pairing of actual shabby cafeteria patrons and the mural tableau alludes also to the cafeteria types from the neighborhood whom Singer observed for decades and incorporated into his stories, many of them published in Yiddish in *The Jewish Daily Forward*.

Some, like Florence Strauss, shared with Davidson their enthusiasm for simple pleasures and the familiarity of daily meals taken there. He embraces the warmth of these

acquaintances and the mutual trust. Yet there is something grotesque about this mother-son couple that he accentuates by photographing with a wide-angle lens from a steep angle. The son's bulky torso leans on and overwhelms his thin mother, who remains seated for their portrait. The image presents a relationship that is ambiguous — indeed, gender identities that are ambiguous. Although the photograph was made in a moment of apparent relaxed rapport, Davidson captures Martin's geeky facial expression and effeminate softness. While an affectionate image, there is an underlying awareness that these individuals are on the margins of society. As such, it relates to his earlier work and artistic associations.

In 1958, Davidson had explored society's (and his own) ambivalent attraction to and repulsion by the distortion of normal human form in a sensitive essay about a circus dwarf, Jimmy. Davidson was a friend of Diane Arbus, who documented the bizarre, taboo, and misshapen people on the fringe of society. He recognized in Arbus' work, which he admired and introduced to a photography course he was teaching, "the pain of her aloneness." A number of the Cafeteria photographs are portraits of aloneness, whether individual [Plate 9] or in groups [Plate 7, 8, 10]. A poetic melancholy, reminiscent of photographs by Robert Frank and Walker Evans, pervades these images. Although Davidson does not intrude on their reveries, he implies their shared history as Jews displaced and shattered by their experiences in the Holocaust. These are exiles from a vanished Europe who have not found a new idyllic life in the New World, but rather, who sit apart, quiet and waiting. He invites us to imagine their secret lives, hidden for twenty-five years. In reaching for his own roots, Davidson depicts these uprooted strangers unable to re-root themselves in modern New York.

The Garden Cafeteria of 1973, typical of a waning genre of downscale restaurant, served as a community center for those who needed only the price of a cup of coffee. From the outside, as seen in "Woman in front of the Garden Cafeteria" [Plate 5], it retained the sleek sheet metal façade and neon signage of an Art Moderne urban

commercial structure, much like the uptown Automats and restaurants. This square image, one of group he made with a medium format camera and wide-angle lens, encompasses the entire façade. The distortion underscores its resemblance to the prow of a ship. He has cropped the vertical signage, leaving only the 'den' of Garden, to imply the cave-like interior that served as a surrogate home to the lonely, frightened, and impoverished residents. The unnamed elderly woman, bundled against the bitter cold and collecting money, defines the setting and epitomizes the forbearance and resilience of the denizens inside.

For some of the interior shots, such as "The storekeepers from a candy store on Avenue B" [Plate 17] and "Mrs. Bessie Gakaubowicz, holding a photograph of her and her husband, taken before the war" [Plate 13], Davidson employed medium format cameras with wide-angle lenses and hand-held them with a strobe flash. "The direct flash caused the background to go black, isolating the people from the environment and conveying that sense of silent waiting that permeated the endless rattle of dishes, the fragile movements of the aged and the slow, careful swallowing of food." The flash also thrust the subject into high relief, rendering every facial line like a deep crevice in a parched landscape. The wide-angle camera lens takes in the diners and their entire table setting. The optical distortion monumentalizes the grapefruit, the bagel, and the coffee cups — rendering in pictorial terms the significance of this modest meal in the social lives and nutrition of the elderly. In this shallow space, he and we, the viewers, become their table companions as they share their sadness or consume their meal.

Davidson has described the Garden Cafeteria patrons as "remnants of a past age." In his foreword to the portfolio, Singer describes them as "human remnants" [Plate 4]. Dressed in their old clothes and sharing stories or photographs of deceased loved ones, they are the worn and tattered remains of a once rich fabric of Jewish life and culture. If not for Davidson's empathetic portrayal, they would fade and disappear

from view. Instead, each image attests to the strength and luck that enabled them to survive.

In 1990, Davidson returned to the Lower East Side once again to document its Jewish milieu for a special issue of the Swiss periodical *Du* (October, 1990) honoring Isaac Bashevis Singer. Davidson left the closed world of the Garden Cafeteria for the streets, *shuls*, shops, and old age homes where the elderly and a younger generation of Orthodox Jews merged with newer immigrants from Asia and Latin America. In his panorama of the bustling pedestrian shopping district of Orchard Street [Plate 28], Davidson recapitulates the scene of numerous street views of a century earlier. Orchard Street, in the late twentieth century, became a shopping mecca for bargain hunters, its racks and sidewalk displays replacing the crowded stands and pushcarts of the earlier era. The sole Jew, a *Hasid* striding out of view at lower right, defines the locale.

The inclusion of this young Orthodox man marks a shift in Davidson's work in this neighborhood. Here and in most of the other works of 1990, he explicitly defines this Jewish world by documenting the diversity of Jewish religious, social, and commercial life. The prominence of Jewish activities, Yiddish signage, and the traditionally garbed Orthodox not only links this body of work with ethnographic studies of a century earlier, but also with the outpouring of vintage documentary images of Eastern European *shtetls* that were becoming widely published and displayed at Jewish and Holocaust museums to commemorate the dead and familiarize new generations with this lost culture. He has created something of a pendant to Roman Vishniac's "vanished world," the photographic record of Jewish city and *shtetl* dwellers that he made in the late thirties, on the eve of the Holocaust. Davidson's photographs prove that this world survives and even thrives in the midst of modern New York.

This new theme reflects as well a more personal turn for Davidson—one that presents his ease, acceptance, and curiosity about the observant Jewish world. In the course of

the project, he made a self-portrait [Plate 43] of his reflection in a mirror, holding his camera and wearing a *yarmulke* (which would have been required to gain admittance to the *shuls* and study rooms of the Orthodox).

One group of environmental portraits depicts shopkeepers selling typically Jewish wares: pickles, fish, and Jewish ritual objects. These hark back to the work of Davidson's heroes: Eugène Atget, W. Eugene Smith, Walker Evans, among others, but they display also a bold new intimacy and connection with his subjects.

Two of his images of rabbis [Plates 39, 40] are photographed in extreme close-up. Their piercing gazes engage the camera and the viewer; and we see them as wise, humble, and utterly transparent. The intimacy of the close-up implies the profound trust Davidson had already established. Indeed, the camera was right in their faces, since he composes through the lens rather than cropping the negative afterwards.

In a few instances, Davidson entered hidden or forbidden locations such as the ritual bath or the study house. In one, he stands behind two men engrossed in prayer [Plate 41]. He has made this picture surreptitiously in spite of the proscription against photographing there as well as the Orthodox aversion to photography, considered to be the making of graven images. His photograph of the holy texts, a scroll enveloped in a circle of light surrounded by men in black, conveys the special illumination of the sacred words. One rabbi glances up as Davidson, standing behind another, discreetly releases the shutter. Glimpsed in the distance, the rabbi meets the camera's gaze and acknowledges the apparent transgression. Although they knew that Davidson had a camera, they chose not to stop him, perhaps recognizing in this moment the shared bond of awe and reverence. And in this moment, Davidson is no longer the outsider, but accepted as part of this intimate circle.

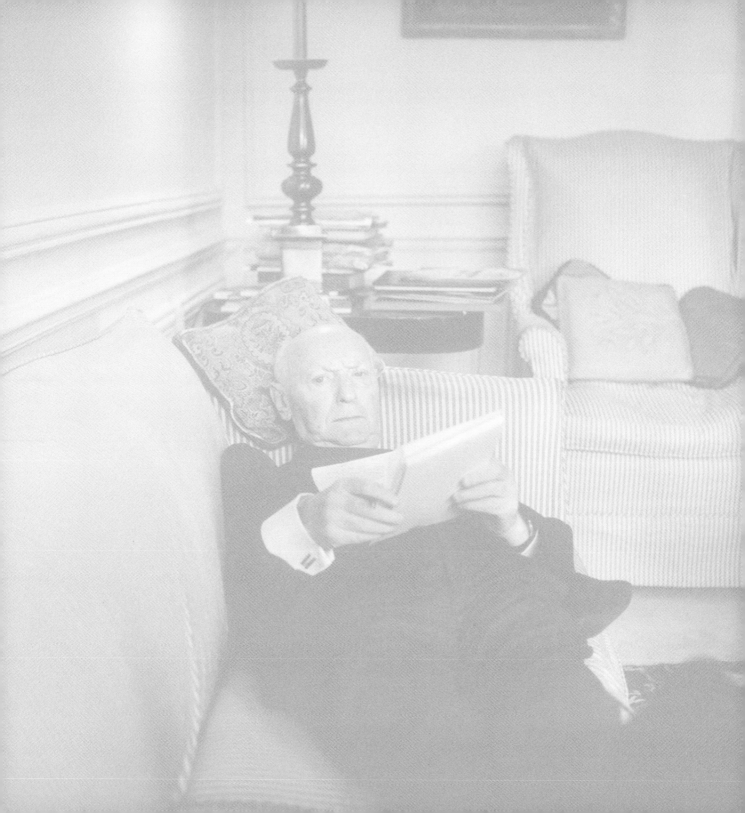

PHOTOGRAPHING SINGER

ILAN STAVANS

In 1969, at the age of sixty-five, Isaac Bashevis Singer, already on his way to becoming one of the most popular of Jewish writers in America, published *A Day of Pleasure: Stories of a Boy Growing up in Warsaw*. Under the Yiddish title of *In mayn foter's bes-din shtub,* most of the autobiographical tales included in it had been originally serialized in 1955 in *Der Forverts,* the far-reaching Yiddish daily in New York City where Singer wrote and first made his reputation. In 1966, an abridged version appeared in English as *In My Father's Court* by Farrar, Straus and Giroux, Singer's new publisher at the time and the one that would remain loyal to him until his death. Fourteen out of the nineteen stories in *A Day of Pleasure* had appeared in *In My Father's Court.* To prepare the new volume, Singer therefore added some previously untranslated material. But what makes *A Day of Pleasure* unique, even remarkable, is the fact that it includes photographs by Roman Vishniac.

Throughout his career, Singer collaborated with a number of artists in various fields, among them directors like Robert Brustein, playwrights like Leah Napolin, actors like Tovah Feldshuh, filmmakers like Menahem Golan, Barbra Streisand, and Paul Mazursky, and children's book illustrators like Maurice Sendak. Little known, although equally significant, are his liaisons with photographers. In *Isaac Bashevis Singer: Album,* which I edited for The Library of America, I included a number of photographic profiles by several prominent artists. Singer was a sought-after celebrity whose pictures multiplied in newspapers and magazines. Dozens of contact sheets are stored in his archives at the Ransom Center in Austin, Texas. But he is connected—either tangentially or else quite closely—with two cameras in particular: Vishniac's and Bruce Davidson's. As it happens, these connections help us understand the role Singer played as a bridge between the Old World and the New.

By association, most people couple Singer with Vishniac, whose art is a staple of Eastern European Jewry. Born in 1897, Vishniac was a Russian-American biologist, art historian,

philosopher, and linguist, aside from being a photographer. He was born in Pavlosk, near St. Petersburg, and immigrated to New York City at the age of forty-three. But before that, he was asked by the American Joint Distribution Committee to travel from Berlin, where he had settled and was doing research on endocrinology while he worked as a photojournalist, to various *shtetls* in the so-called Pale of Settlement in order to document Jewish life. Soon he was traveling to Lithuania, Poland, Slovakia, Hungary, and the Carpathian mountains to document the poverty from which he himself had emerged. These photographs became a mission: this was in the mid 1930s yet Vishniac already believed Eastern European Jewry was doomed for destruction. He took a total of 16,000 images, 2,000 of which he was able to protect from the Nazis, who imprisoned him eleven times and placed him in two different concentration camps. A few of these images were published in 1947 in a book called *Polish Jews: A Pictorial Record*, released by Schocken Books

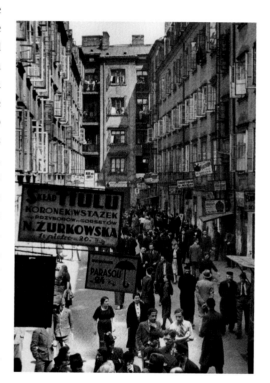

Roman Vishniac, A shopping street in the Nalewki, the heart of the Jewish quarter of Warsaw, 1936-39, gelatin silver print © Mara Vishniac Kohn

with an essay by Abraham Joshua Heschel. Once in the United States, he worked at Albert Einstein College of Medicine, the City University, and Pratt Institute, as well as the National Science Foundation. He is considered a pioneer in time-lapsed

cinematography and light-interruption photography. But his most substantial contributions are the images he took before World War II. In 1983, another volume appeared that consolidated his reputation: *A Vanished World*. Vishniac died in 1990.

Although the two adopted New Yorkers were roughly the same age (Singer was Vishniac's junior by seven years), Singer didn't work directly with Vishniac in *A Day of Pleasure*. It was an editorial idea to pair them. In the acknowledgments, Singer doesn't even thank him but the volume does include a caveat: "Except for those of Isaac Bashevis Singer, his brother, and his grandfather, the photographs were taken by Roman Vishniac between the time the Nazis came to power and the invasion of Poland in 1939. Nearly all of them were taken in Warsaw, a few in nearby towns. The world portrayed in these photographs is essentially the same as the one in the stories, even though the stories take place a generation earlier." The twelve photographs in *A Day of Pleasure* come directly from *Polish Jews*. While they might be only loosely connected, content-wise, with Singer's plotlines, the editor decided to use them as frontispieces to each of his stories.

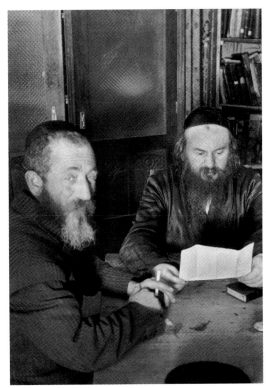

Roman Vishniac, Rabbi Leibel Eisenberg and his *shames*, Lask, 1936-39, gelatin silver print © Mara Vishniac Kohn

In one photograph a Jewish woman is shown selling geese. Another one displays a fruit and vegetable stall in a street market. There are others of coal porters, metal

workers, water carriers, and courtyards in Warsaw. In one famous image, a bearded Talmudic scholar holds four volumes under his arm as he makes his way on the sidewalk with a wooden cane. And another photograph has a number of religious Jews, all male, facing back as they pray in a synagogue. Vishniac's position is usually at face-level: he neither looks up nor down at his subjects. He only had access to black and white film. This is as it should be because it is impossible to visualize the Polish Jews he photographed in color: their fate, we know now, is color-blind.

Without a doubt, Vishniac's photographs are an announcement of catastrophe. The people he captured through his lens have dignity. They also distill another quality: an uncanny naïveté. They seem unaware of the future awaiting them. Of course, none of us is able to predict what the future holds. Still, Vishniac's subjects seem to parade in front of us utterly unaware of danger. Is it possible to be that innocent, one might ask? This quality grants them ghostliness. Vishniac isn't interested in contextualizing them. He doesn't see them as characters in history but outside of it. Indeed, these Jews are almost mythological. The viewer can't but be aware of the treacherousness of the presentation. As we look at them, we know they will be dead in a short period of time. Thus, we approach Vishniac's art as testimony: his photographs are artifacts of a world that is no more.

This ghostliness is also present in Singer's tales of Krochmalna Street, in Warsaw, where he grew up: the author hands them to us as snapshots of disappearance. His parents Pinchos Menachem and Bathsheba, his neighbor Sosha, Reb Asher the Dairyman, and Singer's other creations are all figments of his memory—and, through the art of literature, of ours too. Singer would go on to write three adult autobiographical books. Each of these would be illustrated with work by painters. Posthumously another volume of coming-of-age stories about Krochmalna Street in Warsaw, where Singer grew up, would also be released under the title of *More Stories from My Father's Court.* None of these would ever include other Vishniac collaborations.

Still, people make an automatic link between the two, Singer and Vishniac, because Singer too has come to be known as the memorialist of Eastern European Jews, even though he left Poland in 1935. Even while he was in Europe, he always established a distance between his cosmopolitan universe and the life of impoverished *shtetl* Jews.

The opposite type of collaboration was the one Singer fostered with the Jewish-American documentary photographer Bruce Davidson. They met when Davidson was assigned to photograph him in his Belnord apartment on 86th Street, between Broadway and Amsterdam, where Davidson himself later rented an apartment in the same building. (He asked Singer for a letter of recommendation.) By then they were established artists in their respective fields, even though Davidson was almost twenty years younger and was still searching for his own voice—or better, his own eye. Davidson saw in Singer a parental figure who represented the universe of the Eastern European immigrant who arrived in the Lower East Side through Ellis Island in the last quarter of the nineteenth century to the 1930s.

Born in 1933, Davidson comes from a radically different tradition than Vishniac. Influenced by Henri Cartier-Bresson, his photographs depict the life of marginality. He was born in the Midwest into a Jewish household but only loosely connected with tradition as a child. He moved to New York City in order to pursue his studies and immediately made it his habitat. His photographs of Spanish Harlem and Brooklyn are legendary. There is a quest for social justice in them, although he doesn't intrude in the picture in order to preach to the viewer. He lets his characters speak for themselves. In that sense, there is also the impact of Lewis Hine and Jacob A. Riis in his oeuvre. His mission is to record how the other half lives, so to speak, to bring his camera's eye as close as possible to New Yorkers inhabiting the margins, whose frustration, the viewer constantly feels, is about to explode. His subway photographs in the age of hip-hop graffiti make an era immediate to us, as do his portraits of the

Civil Rights period. Vishniac and Davidson grant their subjects dignity. But Vishniac approaches them in limbo, almost out of history. He deliberately deprives them of a political message. Instead, Davidson embraces ideology, although he doesn't shove it in our face. His pictures are first and foremost esthetic artifacts and only insinuate their politics after their beauty has been experienced in full.

Davidson first photographed Singer inside his apartment and in the surrounding areas. Then Singer invited him to travel to the Lower East Side and join him at the Garden Cafeteria. Soon after Davidson returned to the cafeteria on his own time and time again, seeking to capture the evanescent emotions of its aging clientele, made up primarily of refugees from the Old World. Somehow, the faces of the storekeepers from a candy store on Avenue B [Plate 17], the tango-dancing cashier [Plate 14], and Mrs. Bessie Gakaubowicz, the "French lady" from the concentration camp [Plate 13], are later-day incarnations of Vishniac's subjects but on this side of the Atlantic. This is what those who survived the Holocaust became: depressed, mistrustful, contrite.

Ironically, Singer's loci are never the Lower East Side. Holding a six-month tourist visa, he sailed from Cherbourg to the United States and on May 1st arrived in New York City, where he was met at the dock by his brother Israel Joshua and the journalist and translator Zygmunt Salkin. He first lived with Israel Joshua in Seagate, a gated community not far from Coney Island in Brooklyn. He then moved briefly to a rooming-house on East 19th Street in Manhattan, then lived for a time in Croton-on-Hudson and after that in Sheepshead Bay in Brooklyn. After he and Alma Haimann Wasserman married in 1940 in Brooklyn City Hall, they moved to a small apartment on Ocean Avenue in Brooklyn. Almost a year later they moved to upper Manhattan, to an apartment on 103rd Street, then to another one on Central Park West. It wasn't until 1965, shortly before *In My Father's Court* appeared in the United States, that he and Alma acquired their place in the Belnord. Hence, Coney Island and Brooklyn in general, as well as the Upper West Side, were his habitats. Singer would go regularly to *The*

Jewish Daily Forward offices on 175 East Broadway to file his stories, essays, and reviews. On his way back, he would stop at various restaurants, including the Garden Cafeteria, a place he would eventually call "a second home."

Cafeterias are to Singer what bars are to Hemingway: at once a hangout and a private office. In Singer's stories, characters sit and wait, and while they wait, they schmooze. Schmoozing is a way to purge their lives. There are also stories that rotate around a cafeteria, most famously "The Cafeteria," originally published in *The New Yorker* and collected in 1970 in *A Friend of Kafka and Other Stories*. (The story was adapted into a TV movie by Amrak Nowak that aired on PBS in 1984.) It is about a female refugee who imagines that Hitler is alive and living in New York City. Singer describes her thus: "She must have been in her early thirties; she was short, slim, with a girlish face, brown hair that she wore in a bun, a short nose, and dimples on her cheeks. Her eyes were hazel—actually, of an indefinite color. She dressed in a modest European way. She spoke Polish, Russian, and an idiomatic Yiddish. She always carried Yiddish newspapers and magazines. She had been in a prison camp in Russia and had spent some time in the camps in Germany before she obtained a visa for the United States. The men all hovered around her." The concept of the American cafeteria was extraordinarily attractive to Eastern European immigrants. The fact that all the choices were available before one's eye, that it imposed a self-served style, that one could stay without being thrown out and talk to people at other tables, endlessly, and especially the fact that one could eat as much as possible, made the place a metaphor of America's democratic spirit. Singer wrote in cafeterias. He spoke to people whose stories would later on metamorphose into fiction. And, as his reputation grew and he became famous worldwide, he held court in cafeterias. "I like to take a tray with a tin knife, fork, spoon, and paper napkins and to choose at the counter the food I enjoy," he wrote. "Besides, I meet there the *landsleit* from Poland, as well as all kinds of literary beginners and readers who know Yiddish."

In 1972 Davidson received a grant from the American Film Institute to make a documentary on an American writer. He persuaded Singer to be his subject and the two went to the Garden Cafeteria. He wanted to use Singer's story "The Beard," included in the by-then recently released volume *A Crown of Feathers and Other Stories*, as his springboard. The story is about a handicapped writer, Bendit Pupko, who makes it rich, and his wife, Mrs. Pupko, who had a thick beard. It would be a mix of fiction and nonfiction, with Singer himself playing the narrator. A portion of the film was shot at the Garden Cafeteria and the rest in Singer's apartment. The half-hour film became known as *Isaac Singer's Nightmare and Mrs. Pupko's Beard*. It aired on PBS in late 1972, paired with a movie about Marc Chagall. Once Davidson finished the project, he took to the cafeteria as his site: he wanted to explore the inner life of its clientele. In an essay by Davidson published in *New York Magazine* on October 15th, 1973, that featured a handful of the Garden Cafeteria photographs, he wrote: "The subway stop is East Broadway. Outside, at the corner of Rutgers Street, is the Garden Cafeteria, a Jewish oasis for forty-two years. I first went to the Garden with Isaac Bashevis Singer when I was making a film on his story, "The Beard." Singer had spent a lot of time there and knew many of its people, some of whom had survived the Nazi concentration camps. I became interested in the cafeteria and in the survivors who now lived in the Lower East Side. So everyday, for weeks, I went to the Garden, took a check, got some coffee, and sat down with people at the small tables along the wall. But how does one begin a conversation with someone who may have lost all his family in the Nazi camps?"

The conversation, as it turns out, is visual. Davidson used Singer's same method: he sat around and made the refugees talk to him. But he wasn't after their story, at least not in the literary sense. He sought a sense of intimacy, a way into their inner emotions. He wanted the survivors to be comfortable in front of his camera. The results are astonishing. Davidson didn't stop there, though. Time would enable him to return, not only to the Garden Cafeteria, but to the neighborhood. More than fifteen years later, the German-language magazine *Du*, planning a special issue on Singer,

commissioned him to wander around the Lower East Side. It was then that Davidson, again using Singer as his inspiration, photographed Orthodox Jews in various parts of the neighborhood, indoors and on the street. Curiously, the issue appeared the year of Vishniac's death. By then Davidson had grown more aware of his Jewish identity. For unlike the images of the early 1970s, there was now an obvious religious component in the pictures of menorahs, schoolchildren, fish and pickle vendors, Torah scribes, *minyans*, and *tefillin* users. The photographer visits his subjects in their habitat: he allows them to display their concentration camp tattoos to underscore their covenant. Again, Davidson doesn't shy away from intimacy. As in his portraits of the Brooklyn gang and of Spanish Harlem, these photographs open for us a window to the inner world of a whole community. It just so happens that this community is also Davidson's own.

This addition to the Garden Cafeteria series announces a surprising rotation. Vishniac's Jews in the Pale of Settlement might have vanished, but Davidson finds them reincarnated in the Lower East Side; Vishniac photographed children learning Torah in a *cheder* in Warsaw and Davidson finds their adult döppelgangers in *shul* in New York. But by the time Davidson gets to them, they are no longer Singer characters, at least not in the strict sense. For once Singer settled in America and prospered as a writer, his world changed: in his fiction, people in the Old World are devout; but in the New World, they are comparatively lighthearted. Religion doesn't interest them any longer. Their obsessions now are different: sex and fortune, for instance.

In the Ransom Center, I also came across a bunch of doodles by Singer himself: one of them has a bird with a long beak surrounded by scribbles in English; an Orthodox Jew is in another one; and a third displays three men, one has long sideburns, the second has a prominent beard and is smoking a pipe, and the third one is bald. I included these doodles in *Isaac Bashevis Singer: Album*. Somehow they look like the work of a

filmmaker conceptualizing his scenes. Davidson, in his collaboration with Singer, has several photographs in which he, his wife Emily, and Singer are together during the filming of *Isaac Singer's Nightmare and Mrs. Pupko's Beard*. But, to me, some of the most interesting pictures of Davidson's cycle are the ones he took of Singer himself. In an interview with Gabriele Werffeli, former editor of *Du*, he describes Singer as having "a great sense of curiosity." He also says that it is "hard to fathom genius. I am sure [Singer's] mind was more complex than I could have uncovered in pictures. All in all, I was attracted to the atmosphere of his life. It was foreign to me." Of course, one can only imagine what a Vishniac portrait of Singer would have been. I'm tempted to say *elegiac*. As a photographer of the human experience, Vishniac only related to the experience in Europe before World War II. The work he did as a photographer in America is almost exclusively in the area of biology. Singer was a bridge between the immigrants' past and present but Vishniac was attached only to the former.

Davidson symbolizes the latter. He came across not Singer the Pole but Singer the American Jew. And, thankfully, he did have the opportunity of photographing him. In truth, to me, some of the most mesmerizing images Davidson brought out in their collaboration are the Singer portraits. In one, Singer, an annoyed, cantankerous old man, is in bed finishing his breakfast [Plate 22]. In others he is relaxing on his sofa while correcting proofs [Plate 23] or he's feeding the pigeons on Broadway [Plate 19]. He is also seen with Alma, looking into the camera's eye while sorting out his mail [Plate 21]. In one of my favorites he is bending, with a disorganized manuscript in his hands [Plate 24]. The place looks chaotic only to the naked eye. In truth, it is his niche, the private room where his fictions come alive. And in arguably the most memorable picture—the one that connects the dots in Davidson's work on and with Singer—Singer stands on an Upper West Side Broadway traffic island, near a Woolworth's, his hat and dark jacket on, his eyes pale and red-rimmed, the right hand in his pocket and the

other one loose around his waist [Plate 18]. Singer is looking at a bag lady sitting on a bench, covered with layers of coats and ... a book open in front of her.

A remnant of the Garden Cafeteria? These portraits were taken in winter of 1978. Symptomatically, Davidson's Lower East Side photographs are all in black and white. But the close-ups he took of Singer, as well as the images where Singer is in his apartment, on the street, and in the Garden Cafeteria, can be in black and white and in color, as if Singer was himself an in-between, caught between modernity and a tragic past. This series is extraordinary: Singer is framed before us, in full focus, a loner in New York, his skin pale as snow, his teeth rotten and gapped, his cunning eyes emphasizing an almost histrionic demeanor [Plate 27]. He exudes an overwhelming sense of confidence in front of Davidson's camera, but he also keeps his distance. Who is he?

ℒ

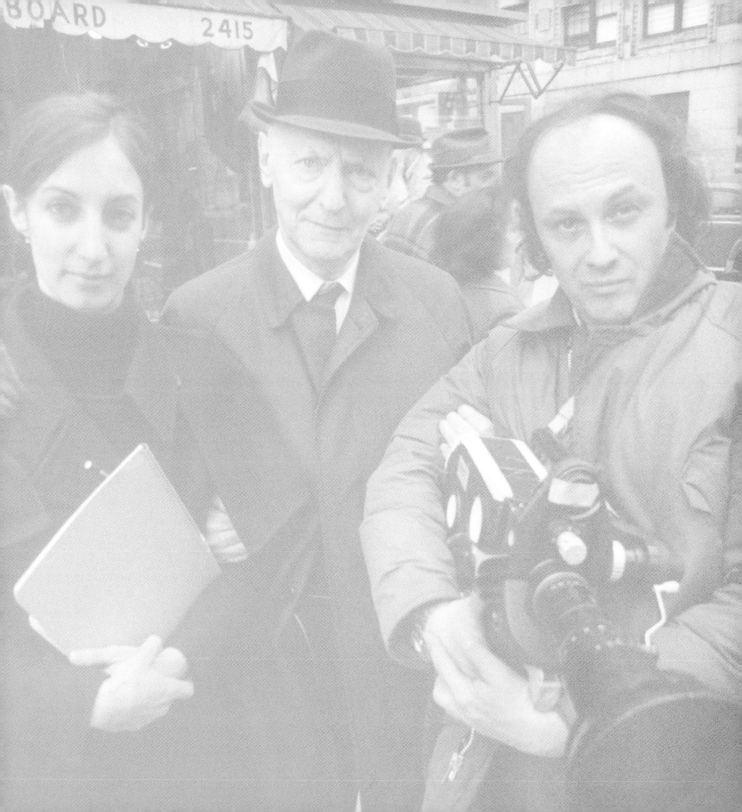

"I LIKE TO BE CLOSE ENOUGH TO THE PEOPLE I PHOTOGRAPH FOR OUR AURAS TO INTERSECT."

INTERVIEW WITH BRUCE DAVIDSON

GABRIELE WERFFELI

GW: You were a regular at the Garden Cafeteria on East Broadway in the first half of the 1970s. At the time, you documented the life of Jewish refugee immigrants on the Lower East Side. Then you went back to that neighborhood in 1990, looking for remnants of the life Isaac Bashevis Singer portrayed in his stories. When was the last time you went to the Lower East Side?

BD: Last night. I went to Katz's, the world famous deli on Houston Street. The table behind us was full of Asians, and the waiter was black. It was crazy. He said he was trying to learn Yiddish because it was such a beautiful, expressive language.

GW: This may be the best thing that happened to Katz's since chopped liver.

BD: The place was very well booked, but not with the old-timers that I remember going there.

GW: Some of the characters you are talking about must be in their nineties today, if they are still alive.

BD: Even if they were alive, it would be very difficult to find them. For one, their hangouts, the cafeterias, are gone. And then they probably had facelifts and are on Atkins.

GW: Something else is going on, too, and it has been going on in New York City forever. It's what you saw in the patrons and the waiters at Katz's last night. People may come to New York from the Far East or the Caribbean and become experts on pastrami in no time! All the different tastes of culture come together in this city – and the first place they usually meet is in your stomach. Food is the first thing you try and become familiar with, way before you take a Yiddish class. The reverse is true, too. Native New

Yorkers gobble up everything new that arrives. And certain neighborhoods, like the Lower East Side, are more prone to this intercultural exchange than others.

BD: That is right. The Lower East Side is a lily pond. At first, there are two lilies in it, then four, then eight. And then one morning you wake up and half the pond is filled with water lilies. And the very next morning the whole pond is filled. It's a mathematical law, the geometric progression. The same is true for the character of the Lower East Side; it changes slowly at first and then overnight.

GW: Change is constant here.

BD: I seem to latch onto things in transition. What is true for my pictures of the Lower East Side is true, also, for my other work. The life-style of the Brooklyn gang was in transition when I documented it; drugs were already starting to reach the city. Documenting the Civil Rights movement was documenting a whole nation in transition —and a victory over unimaginable resistance to change. When I started to explore Spanish Harlem in the mid-1960s, the reputation of this neighborhood was lagging far behind the real world I entered on East 100th Street. Whereas showing my New York subway pictures from the 1980s today has people reminiscing over the artistic power of graffiti. I have called my Civil Rights book *Time of Change*, but that could easily be the title for my whole body of work.

GW: Our attraction to unknown worlds and our choices to enter them, whether we make them consciously or intuitively, always reflect who we are at that time.

BD: That is very true for me. My work is my education. It is how I live, how I learn, how I take in information. It is how I express myself. And what I have discovered, I show to the world.

GW: What brought you into the Garden Cafeteria on the Lower East Side in the early 1970s?

BD: The atmosphere. It was wonderful. People were sitting there by themselves, sipping coffee. Their loneliness attracted me.

GW: Loneliness as a human condition or as a reflection of your own?

BD: Both. In general, I do not read to preconceive. Instead, I enter the book of life and turn the pages while exposing film. It is after I finish that I realize I went through something and absorbed the experience. In other words, I enter the picture.

GW: And the picture becomes part of you. It is the old question: Is it enough to look into a mirror to see ourselves? Or do we need one more source of reflection—the other—to be able to find out who we are?

BD: I need both. After I make a photograph, I see myself in it.

GW: Your work at the Garden Cafeteria is closely connected to your two film projects inspired by stories of Isaac Bashevis Singer.

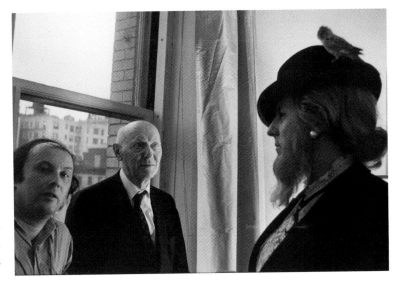

Bruce Davidson, Isaac Bashevis Singer, and Jack Wiener as "Mrs. Pupko," 1972

BD: I had received a grant from the American Film Institute to make a documentary on an American writer. Documentary filmmaking wasn't what I was interested in. So, to disguise the fact that I was using a grant for a documentary to try to make fiction, I came up with the idea of having Isaac Singer appear and act in one of his own stories, "The Beard."

GW: Part of that movie was filmed at the Garden Cafeteria.

BD: Yes, the very first day we were at the Garden, I had to let the soundman go, and that reshuffled the whole crew. I ended up filming the whole movie myself — not a desirable situation to be in as a director. At the end of that first day, Singer came over to me and said, "Don't worry. The worse this movie is going to be the better it will be." The rest of *Isaac Singer's Nightmare and Mrs. Pupko's Beard* was shot at the Singers' apartment in nine days; and it went on to win first prize at the American Film Institute Festival—for fiction.

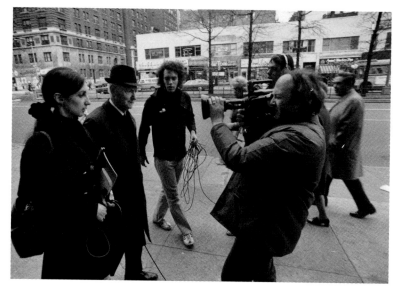

Emily Haas Davidson, Isaac Bashevis Singer, and Bruce Davidson and film crew on Broadway, 1972

GW: You wanted to continue with *Enemies: A Love Story* for a major Hollywood studio.

BD: But that never came through and I returned to still photography for good. Had I

made *Enemies*, though, the movie would have looked like my photographs. At the Garden, I always felt inside a Singer story.

GW: You could have done the casting there, too.

BD: These were the faces Singer had lived with before coming to America. But he was never sentimental about their lives, neither the one they led in the Old World, nor the one they were living here in the New. He was never part of that life anyway. He was no Irving Berlin. He wasn't born on the Lower East Side; he never even lived there. He only went down there to drop off his stories at *The Forward* office and to sit with his cronies at the Garden over a dish of rice pudding and a cup of coffee.

GW: But his characters and his readers lived there; often they were one and the same.

BD: While he was headed uptown: marrying a German Jewess, Alma, revering Dorothea Straus, the wife of his publisher, all his life. She was untouchable. When we were making the movie, he scolded me, "You can't leave Dorothea waiting outside all by herself." I said, "But, Isaac, the scene is: she rings the bell and you open the door to greet her." But he didn't want to hear any of it: of leaving her alone outside the apartment. A lady!

GW: He was funny that way, wasn't he?

BD: Indeed. The first time I asked him to redo a scene from another angle, he said, "It is impossible, I can't do this again. Just imagine if God had said, 'Let there be light!' four times."

GW: You also interviewed the patrons you photographed at the Garden Cafeteria. Here is what one of them said: "This place means to me a lot, because in 1948, when I came

to this country, I had difficulties going into restaurants and I had to beg for what I wanted to eat. In the cafeteria, I felt at home, just like I would be in Warsaw, in 1939, before the outbreak of the war. This was my refuge. First of all, besides getting the meal to my taste, a *haimish* taste of Polish Jew, I found a gallery of Jewish living writers—Asch, Singer, Leivick—who I adored, since I came to my senses. Not only I adored, but my late mother, who died in Auschwitz, adored and dreamed to see. Fortunately, I find them in this restaurant in life. How should I say it in my simple way with my limited vocabulary—I found a haven, a spiritual haven seeing these people. And wasn't it wonderful that some of them liked the same foods that I liked! Herring fish ... it meant that actually nobody could destroy the Jewish people. For instance ... the owner of the Garden, he's a symbol of a plain guy. Former waiter made a place that everybody could come in. A literary man could come in, a writer, or a longshoreman could come in, as long as he's a *mensch*."

BD: It was a kind of paradise.

GW: That is what the tango-dancing cashier thought: that heaven was the Garden Cafeteria, where you could sit all day with friends, eating, and never pay the check.

BD: I often saw the same people, like Florence, who worked at the *bialy* factory on Grand Street. She came every night and for lunch, and sometimes for breakfast after she had worked the nightshift, "I like the food here, and I like *bialys*, so why not eat them here too?"

GW: Let's move on from the first half of the 1970s to 1990 when you went back to the Lower East Side. Almost twenty years had passed since you last worked there; almost one generation had grown up. What had changed?

BD: Certainly, I had changed. In the earlier work, I was not sure who I was. By then, I had had a pretty good idea for some time. But there were more apparent changes than that: the Garden Cafeteria had become a Chinese restaurant.

GW: I cannot see religion in the earlier photographs. Your later work suggests that the Jewish life left on the Lower East Side in 1990 was primarily religious life.

BD: When I went back in 1990, I felt strongly that Jewish culture on the Lower East continued as the neighborhood was changing with Chinatown expanding and new ethnic groups moving in. I attributed this to a strong belief, tradition, and spirit. I wanted to treat the pious with dignity and respect, and not portrayed as strange or exotic subject matter. *Tefillin* are small black leather boxes strapped to foreheads and arms of men during prayer. They contain hand-written passages of the Torah. It has been noted that they correspond directly to the acupuncture points used in traditional Chinese medicine. All of this I wanted to show in my photographs.

GW: I have always been amazed how close you are to the people in all your pictures. In these pictures you are very close, physically close.

BD: I like to be close enough, so that our auras intersect.

GW: In some of these photographs, you are with religious men in prayer.

BD: Some believers did not want to be photographed. But at times, an observant person would make a personal choice and allow the intrusion of the camera. Others decided to ignore its arrogance.

GW: What kind of personal choices?

BD: I think of the rabbi whose *tefillin* are wrapped around the numbers tattooed on his forearm. He wanted me to take this picture for us to remember the Holocaust and that he had survived it. He had lived before it and after it: a pious man, still alive for almost a century, serving his God for almost one hundred years — a witness to everything that happened during his lifetime.

GW: Then there were the two brothers, the lawyers.

BD: They had been born in the neighborhood and worked as attorneys for many years together. They charged very little for their services and all the contributions they made they did anonymously because they believed a *mitzvah* is only a *mitzvah* if you are not recognized for doing good. So, these brothers refused to be photographed because they felt it would have been vain to have their picture taken.

GW: Instead, you were allowed to take another very intimate image of the Singer brothers. Both are Orthodox rabbis who engage you with unwavering gazes.

BD: Rabbi Joseph Singer taught me the expression *Moyshe kapoyr*. During *Tishah B'Av*, a nine-day mourning period commemorating the destruction of the Temples, you are not supposed to eat meat. However, Rabbi Singer made a special dispensation prayer to give the elderly people on his food program meat twice during *Tishah B'Av*. Now Rabbi Singer, who is Orthodox, used the same catering service for his program as did a Conservative rabbi in the Bronx. But that Conservative rabbi didn't want to hear of any dispensation. "*Moyshe kapoyr!*" Rabbi Singer said, "Mr. Contrary" in Yiddish — the guy who does everything in contradiction.

GW: Rabbi Singer actually looks a bit like Isaac Singer with his pale, knowing eyes.

BD: One evening in his study during services a policeman came in, opened the fridge for food and helped himself to coffee, at the same time the phone was ringing, and all the while the Rabbi and his *minyan* were praying. It was a classic Singer scene.

GW: How true. And even in the early 1990s, some of his characters are still very present on the Lower East Side.

BD: Some scenes have hardly changed since the first documentary photographers, Lewis Hine and Jacob A. Riis, came across them a hundred years ago.

GW: Like the peddlers and the food stalls?

BD: Yes, guys like Hershy, the fishmonger, who even looks a little like a fish.

GW: What do you mean, a little? We cannot be certain that he wasn't created after the fish.

BD: Hershy has been in the fish business on the Lower East Side for over fifty years. He told me a story of a lady who shopped with him for over forty years. Every week she would come in to buy a carp. Even after she had gone completely blind, she would not let her son come by himself. And to the day she died, Hershy would hold up the carp but the blind woman would insist that he lay the fish down so she could see if it wriggled and was really alive.

GW: How did you meet Isaac Bashevis Singer?

BD: In 1965, I had an assignment to photograph him at his home on 86th Street. As I was riding the train uptown, I was sitting across from a beautiful girl. During the whole ride I tried to think of a way to meet her, but I just couldn't come up with anything appropriate to say. So, when I got to Singer's home, I was still so taken with

the beauty of the girl—and my failure to make contact with her—that I shared my story with him. However, he just brushed it away with his hand, saying, "Ach, that has happened to me many times."

GW: You moved into the same building later.

BD: Yes, but that was coincidental, although I did ask him for a letter of reference. I remember saying to him over the phone, "Mr. Singer, I would do anything if you wrote that note for me." And he shot back at me, "I am sure you would, Mr. Davidson. The more interesting question is what you would do if I didn't."

GW: Oh, the intricacies of male bonding!

BD: I also recall our first social encounter. It was his wife Alma's birthday. She had invited her girlfriends and my wife Emily for coffee at their apartment. So, Isaac asked me to come down as well, since he didn't want to spend that much time with his wife's girlfriends. When I arrived, he ushered me past the ladies into his study, seating me between his books and piles of manuscripts, and opened the conversation, "Mr. Davidson," we were still on formal terms then, "have you ever been to an orgy?" "Well, not really," I answered, "but recently my wife and I were at a dinner party in San Francisco. After the meal, the host and his wife asked their guests to join them in the hot tub. So, we were all sitting outside in the tub, overlooking San Francisco." "And, Mr. Davidson, did you have an erection?" he inquired. "Well," I said, "you know we were there with our spouses at a dinner party, among all the other guests. Mr. Singer, if you were sitting in a hot tub with your wife and the group of friends she is having coffee with right now, would you have an erection?" "Let me tell you, Mr. Davidson," he said, "in that situation, God himself couldn't have an erection."

GW: That must have set the tone of your relationship.

BD: Yes, it did. He was great to work with, whether it was the movie or the still photographs I made of him. He was very photogenic. He was candid and charming at the same time, and he had a lot of play in him. He could change moods. You see it in the pictures. He could become one of his characters, a troublemaker — not in a mean way, but someone who would mention something at a party that would accidentally give away someone's affair.

GW: As long as it wasn't his own.

BD: Probably. And he is the only one who ever wanted to look into my camera to find out what I see. One day, he also insisted on taking a picture of me. I have that picture in my contact sheets. Isaac had a great sense of curiosity. The way he looked through my camera reminded me of that box they had when I was a kid. You could put your feet in and see the bones of your toes — a fluoroscope.

GW: Isaac Singer had the reputation of being a very dominant man. You seem to have deflected that well.

BD: We had mutual respect for each other's work. I didn't know more about his writing than he knew about my photography but we both knew each was important. What I saw in him was something I had seen in my grandfather. Although my grandfather was a very silent man who hardly ever spoke, he was very stubborn. Isaac definitely had a stubborn streak in him. In any event, it is hard to fathom genius. I am sure his mind was much more complex than I could ever have uncovered in pictures. All in all, I was attracted to the atmosphere of his life. It was foreign to me.

GW: Foreign and familiar at the same time?

BD: Somehow, yes, familiar. Although the familiarity was in the Jewish life; it was one I never really lived. My family was not too observant. I was, in fact, the first boy in my family to have a Bar Mitzvah. Neither my father nor any of my uncles had had one. And I can't say I was enthusiastic about mine, either. I did not enjoy the classes and I forgot the last four lines of my Torah reading.

GW: Chances are nobody else noticed.

BD: Except the rabbi and one elder, but they didn't want to spoil our day. They wanted us to come back for more. I got my first good camera out of it, too. Years later, working with Isaac allowed me to enter this world on the Lower East Side. His world became a world I could explore, uncover, and enjoy. Isaac Singer allowed me to touch something I had never been able to reach before.

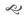

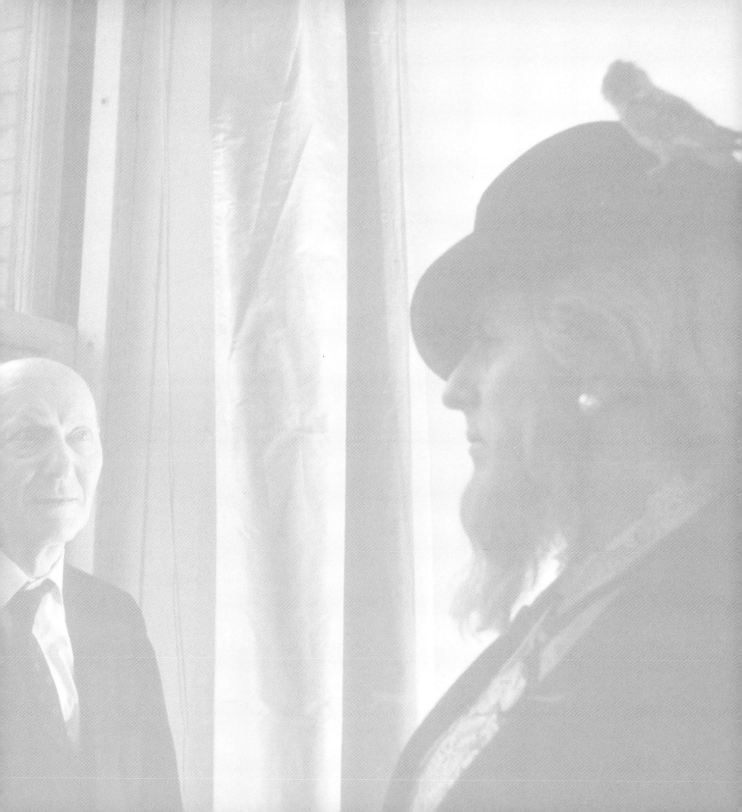

THE BEARD

ISAAC BASHEVIS SINGER

That a Yiddish writer should become rich, and in his old age to boot, seemed unbelievable. But it happened to Bendit Pupko, a little man, sick, pockmarked, with one blind eye and a game leg.

While he struggled with his physical handicaps, the plays he could not finish, the poetry which no one read, and novels which no one was willing to publish, he followed a relative's advice and bought a thousand dollars' worth of over-the-counter stock for two dollars a share. He got the capital in the first place from generous patrons and benevolent societies. The stock went up to almost one hundred times its original value in a matter of months.

Later on, the same relative advised him to buy some half-ruined buildings on Third Avenue in New York. A construction company wanted the land and paid him an enormous sum for it.

No one in the cafeteria which we all frequented ever learned the identity of the mysterious advicegiver, but we knew that Bendit Pupko became richer from day to day. He himself admitted that he wasn't very far away from his first million. Nevertheless, he wore the same shabby clothes he always wore. He sat with us at the table, smoked cigarettes, coughed, ate rice pudding, and complained. "What can I do with my money? Nothing."

"Give it to me," said Pelta Mannes, a writer of fables.

"What will you do with it? Take an egg cookie and a cup of coffee on my check."

Bendit Pupko was the kind of primitive writer who could never learn how to construct a correct sentence, had no notion of grammar, but was talented just the same. I often looked into his published works. They lacked any sense of organization, but on every page I found some lines to surprise me.

He described half-crazed people, chronic misers, old country quarrels which had gone on for so many years that no one knew how they began or what they were about, and complicated love affairs which started in the Polish villages and were carried over to the East Side tenement houses of New York and later to the hotels for old people in Miami Beach. His paragraphs went on for pages. He would insert himself into the middle of his hero's dialogue.

In the United States Pupko learned about Freud for the first time, and he tried to explain his characters according to Freudian theory. He needed an editor, but he never allowed anyone to correct even his punctuation.

Once, when I edited a small literary magazine, he brought me a story which began: "The day was cloudy and the sky loyal." When I asked him what he meant by "loyal," his good eye looked at me with anger and suspicion, and he exclaimed, "Don't bother me with this bookish nonsense. Either publish it or go to hell."

He grabbed his manuscript and ran away.

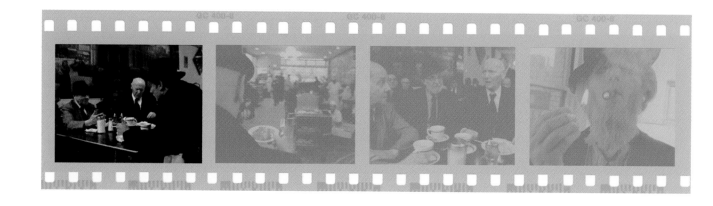

He had lived in America for forty years and never learned more than a handful of English words. He never read anything besides his Yiddish newspapers. Psychology he pronounced "pyschology." Someone told me that a dictionary could be compiled of Pupko's errors. But at times he spoke like a sage. He lived somewhere in Brownsville and had no children.

A man told me that Bendit Pupko's wife had a thick beard which used to be black but had since turned gray. He never took her anywhere. Nobody knew why she didn't shave off her beard.

In my circle I learned long ago never to look for explanations. A comedian of the Yiddish theater who was know for his salty language suddenly became religious, let his sidelocks grow, and settled down in Jerusalem in the Mea Shearim quarter, where the most zealous Jews lived. An Orthodox rabbi divorced his wife, left his synagogue, and went over to the Communists. Two Hebrew teachers divorced their husbands and went to live together as lesbian lovers. Even Pupko's getting rich would not have surprised us too much, but he never let us forget about it. Every day he came and told us about his latest financial accomplishments. He began to advise us how to invest our savings.

One day he boasted to us that the critic Gabriel Weitz was writing a book about him. This we could not believe. Weitz had written unfavorably about Pupko's work at every opportunity. He called him an ignoramus, a village philosopher, and a contriver.

We all asked, "How is this possible?" Bendit Pupko winked with his bad eye and smiled cunningly. "When you grease the wheels, you ride well." Then he quoted a saying from the Talmud: "Money can purify a bastard."

Pupko spoke to us openly. "All these literary faultfinders can be bought for a pittance." He, Pupko, had talked business to Gabriel Weitz. "How much would it cost, buddy?" And the critic had given him a price – five thousand dollars.

We were all shocked. Gabriel Weitz had the reputation of a serious writer. We had all decided that Bendit Pupko was bluffing. But then a magazine appeared with an essay by Gabriel Weitz about Bendit Pupko, which was announced as a fragment of a longer work. In it Gabriel Weitz spoke of Bendit Pupko as a classic. He called him a genius. He was eloquent concerning Pupko's importance to Yiddish literature. Bendit Pupko did not lie: Gabriel Weitz had let himself be bought for five thousand dollars.

I said to Bendit Pupko, "What do you gain by paying for such things? What is the value of such fame?" And Bendit Pupko replied, "You must buy everything. If you have a wife you have to provide for her. If not, she'll sue you. If you have a mistress you have to take her to a restaurant, pay for her hotel, and shower her with presents. Your own children would become your enemies if you stopped supporting them. Sooner or later everybody sends you a bill. In that case, why should fame be different?

He said to me, "You too will praise me one day."

These words made me shudder and I replied, "I have a high opinion of you, but there isn't enough money in the world to make me write about you."

He laughed and immediately became serious. "Not even for ten thousand dollars?"

"Not even for ten million."

Someone at the table remarked, "Bendit, you spoil your own business. He might have written about you sooner or later."

"Yes, it may be," I said. "But now it's finished." Bendit Pupko nodded. "Still, if you knew that writing a favorable review of me would keep you in comfort for the rest of your life, you wouldn't have to scribble your articles and could live somewhere in California, you would think twice. Why is it such a sin to say that Bendit Pupko has talent?"

"It's not a sin and you do have talent. But since you have begun to bribe critics, I wouldn't write about you for anything in the world."

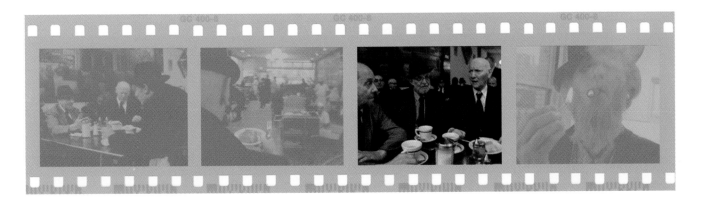

"What if somebody put a gun to your temple? Would you give in then?"

"Yes, it certainly doesn't pay to die for something like this," I replied in our cafeteria style of conversation.

"Well, eat your rice pudding. I'm not offering you ten thousand yet. You'll make it a lot cheaper." And he laughed, showing his teeth, crooked and black like rusted nails.

A year passed, perhaps a little more or less. One day I entered the cafeteria and sat down at our usual table. For a while we chatted about a poem which a colleague had published in a magazine. One of us said it was work of genius and another that it contained nothing but empty phrases. For a while we were engrossed in this controversial subject. Then the writer of fables asked, "Did you hear about Bendit Pupko?"

"What happened?"

"He has cancer."

"So this is the end of all his fortunes," someone remarked. We ate our rice pudding, drank coffee, and the question of whether the poem was excellent or a

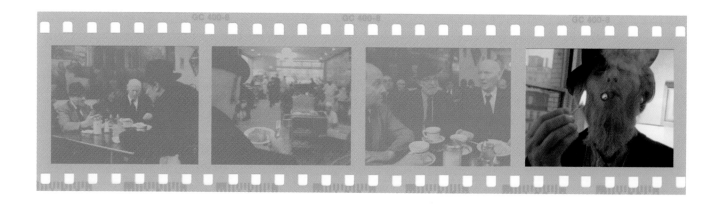

worthless compilation lost its importance. One of us said, "We are disappearing and younger writers don't appear. Twenty years from now no one will know we ever existed."

"And if they do know, how will this help us?"

After a while, I went home to my bachelor quarters. My desk was cluttered with manuscripts, stories, and novels I had never finished. Dust covered everything. I had a Negro woman who cleaned for me once a week, but I had forbidden her to touch my papers. Besides, she was old and half paralyzed. Often when she came I paid her for the day and sent her home because I saw that she had no strength to work. I worried that she might collapse while working in my apartment.

This time I lay down on the sofa and read a letter, the date of which showed that I had received it two years earlier. I found it while rummaging in my inside breast pocket. The sender's address could no longer be read. Then someone knocked at my door. I opened it and what I saw was like a nightmare. Outside stood a woman dressed in a shabby black dress, men's shoes and a hat, with a white beard. She

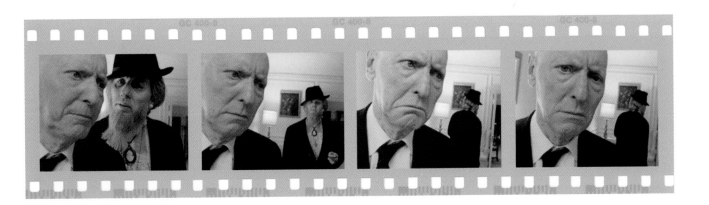

leaned on a cane. I knew at once who she was – Mrs. Pupko. I was afraid my spying neighbors might see her and have something to laugh about. I said, "Come in, Mrs. Pupko."

She looked at me with astonishment. Her cane passed the door first. She said with a mannish voice, "Your elevator doesn't function. I had to climb five flights of stairs."

"I'm sorry, it's an old house. Sit down."

"May I smoke?"

"Yes, certainly."

She took out a cigar and lit it. Perhaps it's a man, I thought. But I saw that she had a large bust. Probably androgynous, I thought.

She said, "My husband is very sick."

"Yes, I heard. I'm very sorry."

"You are responsible for his illness," she said in a strong voice.

Shaken, I asked her, "What are you saying?"

"I know what I'm saying. You told him some time ago that you wouldn't write about him for all the money in the world. For you this was just talk to make yourself sound important. But there is a proverb, 'A blow is forgotten, but a word never.' You hurt him with those words more than you can imagine. How did he deserve it ?

"My husband has great talent. Gabriel Weitz calls him a genius. Bendit has a high opinion of you. When you told him that you would never write about him, he took it very badly. You will never know how this affected him. He came home as yellow as wax. I asked him what was the matter and in the beginning he didn't want to tell me, but I got it out of him. You won't believe me, but from that day on he was never the same. Sick as he was, he was always full of joy. He used to make plans for years in advance. But since that day he never lifted a pen. He began to suffer from cramps in his stomach—"

"Mrs. Pupko, this cannot be true," I interrupted her.

"God knows that it's the truth."

"I'm not a critic. Gabriel Weitz is writing a whole book about him."

"He doesn't think much of Gabriel Weitz. We all know who he is, an intellectual bore. All brain, no feeling. He understands literature like my left foot. Don't think that one can fool Bendit. He may deceive himself but he knows the truth. You are different. He reads every word you write. Sometimes we read you together. We are both insomniacs. We lie awake at nights, and whenever we talk about you he says the same thing, 'He's genuine.'

"Then you had to strike such a blow. He's more sensitive than you imagine. Literature is his whole life. I've been with Bendit for over forty years. Do you realize what it is to share a life for forty years? He reads me every line he writes. Whatever problem he has in his work he asks for my advice.

"We have no children, but his works are our children. You never shared anything with anyone, so you don't understand such things. You write about love, but you don't know what it is. Forgive me, but you describe passion, not love which makes sacrifices and ripens with the years. In this respect Bendit is ten heads taller than you. Do you have an ashtray?"

I brought her an ashtray and she shook the cigar ash into it. She lifted her bushy brows and I saw dark eyes, almost all pupil. I thought the witches who flew on brooms to attend Black Mass on Saturday nights and were later burned at the stake must have looked like this.

"Why do you stare at me like that? I'm a woman, not a man."

"May I ask you why?"

"I know what you want to ask. I grew a beard when I was still a young girl. You may not believe it but I was beautiful then. I tried to shave it or even burn out the

roots, but the more I tried the quicker it grew. Don't think that I'm the only one. Thousands of women grow beards. A beard isn't only a man's privilege.

"When I met Bendit and he kissed my cheek, he exclaimed, 'Zelda, you're growing a beard!' And he fell into a strange rapture. He was in love with my beard. Unbelievable? I didn't believe myself that this could be true. He spoke to me clearly. He was willing to marry me, but on one condition—that I let my beard grow. It wasn't easy to promise a thing like that. I thought he was insane."

"He must have homosexual inclinations," I said.

"Oh, I knew you'd say that. That is what everyone said. From you I expected something more original. He's not a homosexual. People have idiosyncrasies which can't be explained by any theories. It wasn't a small matter for me to comply. It meant complete loneliness. When my mother came to visit me in Odessa after our marriage and she saw me with a beard, she literally passed out.

"I became a hermit. But Bendit's wish was more important to me than any comforts. This is the kind of love which you cannot appreciate. Here in America my isolation became even more complete. I could tell you a lot, but I didn't come here to explain my beard but to warn you that you're killing Bendit."

"Please don't say such things. Bendit is my friend."

"In that case, you are killing your friend."

We continued to talk for some time. I gave Mrs. Pupko my word that I would write about her husband. She said to me, "It may be too late to save him, but I want him to have the satisfaction of seeing something written about him by you."

"May I ask why you smoke cigars?"

"*Nu*, one mustn't know everything."

In my mind I prayed to God that none of the neighbors would see her leave my rooms, but when I opened the door for Mrs. Pupko, I saw my neighbor the spinster lurking in the hall. The elevator was still not working, and Mrs. Pupko had to walk down the stairs. She called out to me, "Be a gentleman and help me down."

She grasped my arm and her breast touched my elbow. For some reason, all the neighbors on all the floors had their doors open as we descended. I heard children screaming, "Mama, look! A woman with a beard!" A barking dog ran out of one apartment and caught Mrs. Pupko's dress in his teeth, and I barely succeeded in driving him away.

That evening I sat down to reread Pupko's works. A few weeks later I had written an article about him, but the editor of the magazine to which I sent it delayed its publication so long that Bendit Pupko died in the meantime. He had just managed to read the proofs and on the margin of the last page he had written in a trembling hand: "Didn't I tell you?"

Once when I sat in the Automat on Sixth Avenue, not far from the public library, the door opened and Mrs. Pupko came in. She was supported by a cane and a crutch. Though a widow for two years, she still had her beard and wore a man's hat and shoes. She immediately limped over to my table and sat down as if she had an appointment with me.

All the customers in the Automat stared, winked at their neighbors, laughed. I wanted to ask Mrs. Pupko why, since her husband was no longer alive, she had kept her beard, but I remembered her words: "*Nu*, one mustn't know everything."

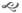

PLATES

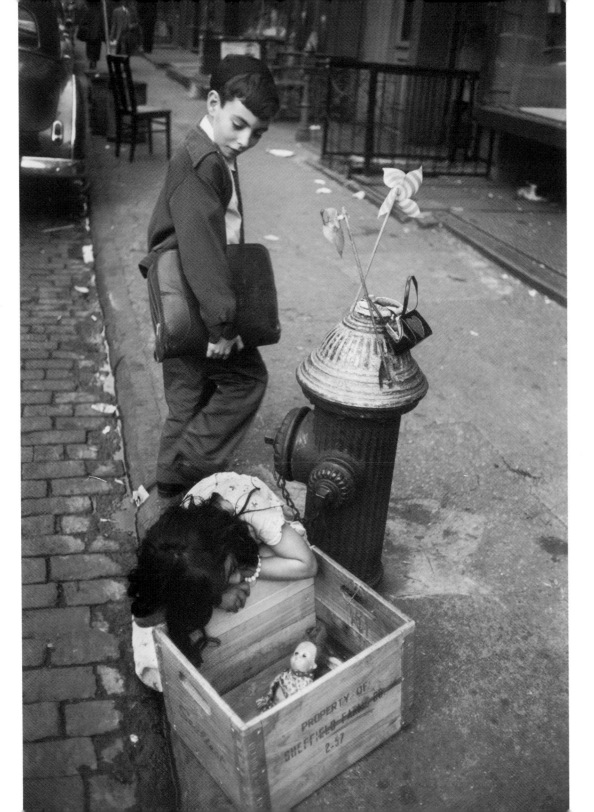

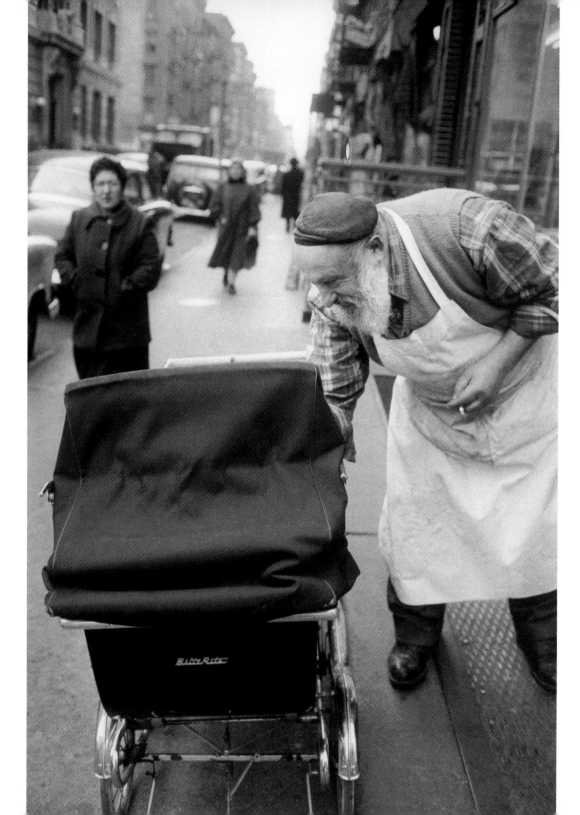

I ~~saw~~ *admire* the ~~'Garden Cafeteria'~~ *photographs* by the
famous photographer Bruce Davidson; with
the title,'The Garden Cafeteria' . For a
number of years while I worked in the
<u>Jewish Daily Forward</u> as a journalist the
Garden Cafeteria was my second home. I ate
there and discussed literature with my
literary chums, gossiped about publishers,
editors and especially about the critics who
didn't like us and whom we disliked. We
also questioned the very purpose of literature.
What can it do; what has it done in the past.and
what can one expect it to do in the future. To
strengthen our arguments we ate mountains of rice
pudding and drank countless cups of coffee.
Of course I observed the types ~~of~~ *and* 'characters' ~~which~~ *who*
visited the cafeteria. Although they were all poor
and wore ~~the same kind of~~ shabby clothes, they
were ~~unusually~~ rich in individuality. Every one
of them complained about the misery of life in
New York in his own ~~individual way~~ *style*. They were
unique ~~in their talk, in their clothes~~ *manner of dress* in every
possible ~~manner~~ *way*. They ~~constituted a treasure of~~
human individuality. I often thought how could one
describe all this in a way which would both inform
and entrtain. Mr. Bruce Davidson has done it not

with a pen, but with his camera. I
consider myself lucky that he took also a
picture of me among all these human remnants. I was
just as poor as they were -- sometimes as
disgusted with life. Here is something for
the eyes of the observer to enjoy and to
remember.

I.B.S.

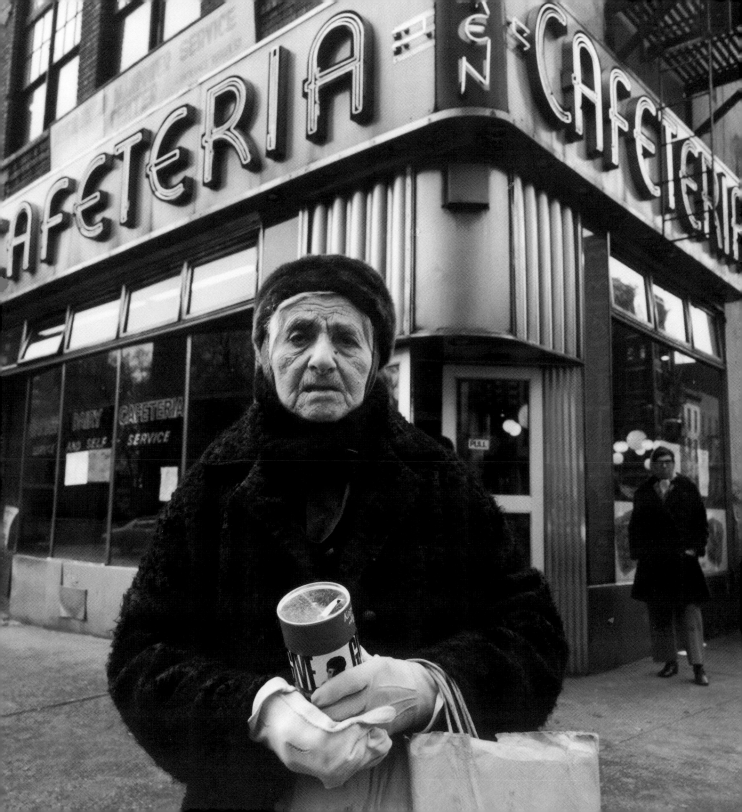

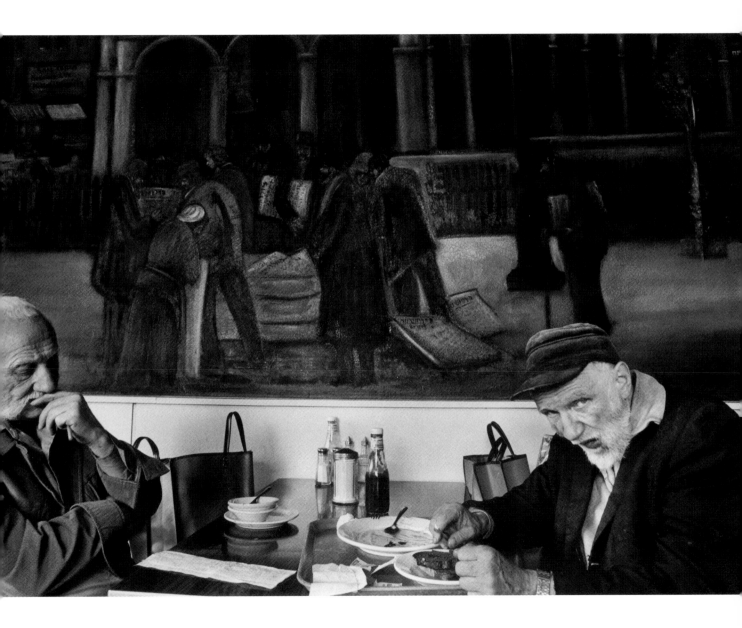

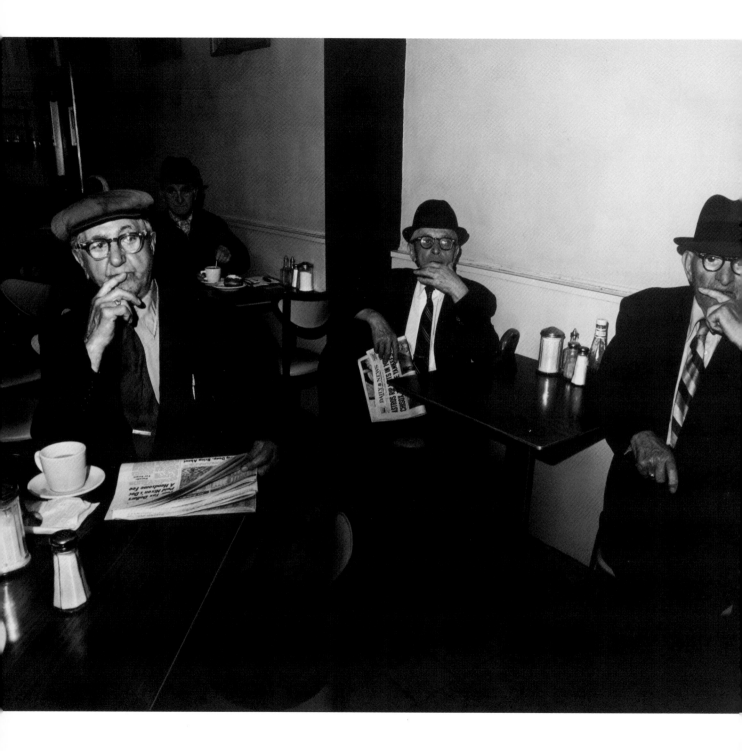

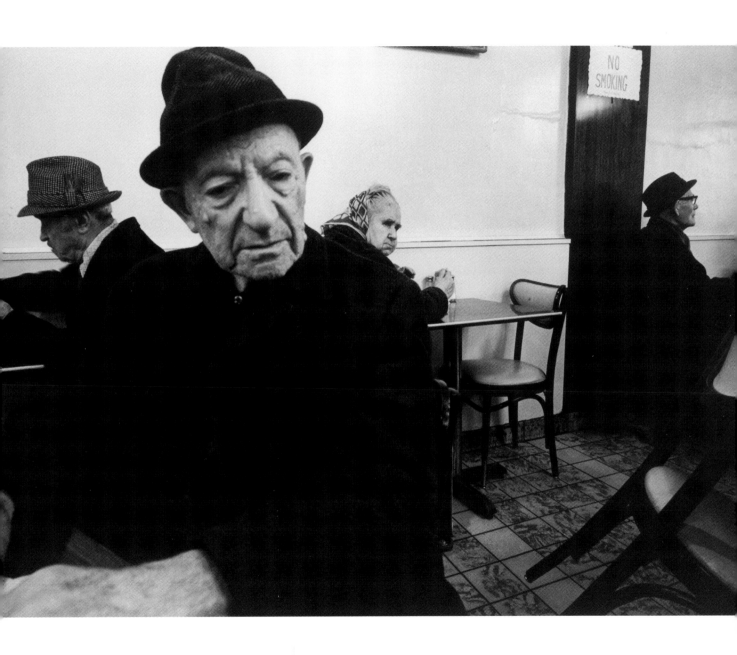

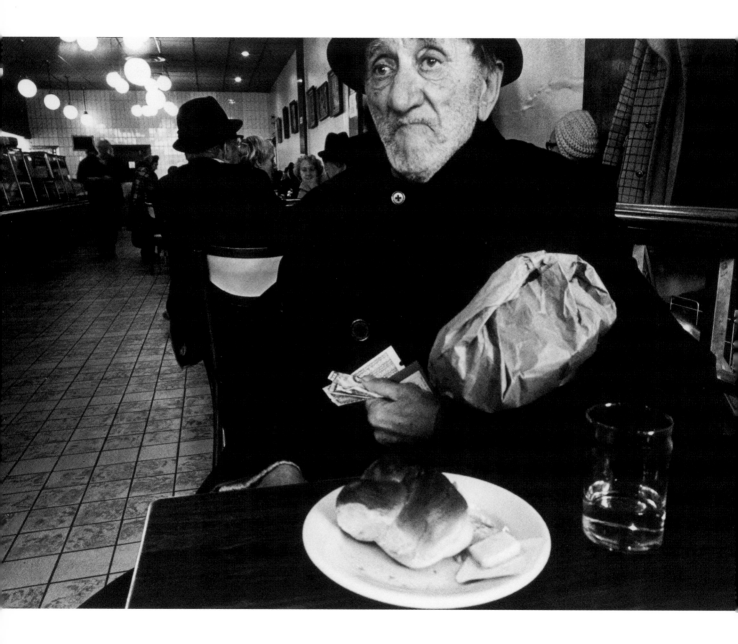

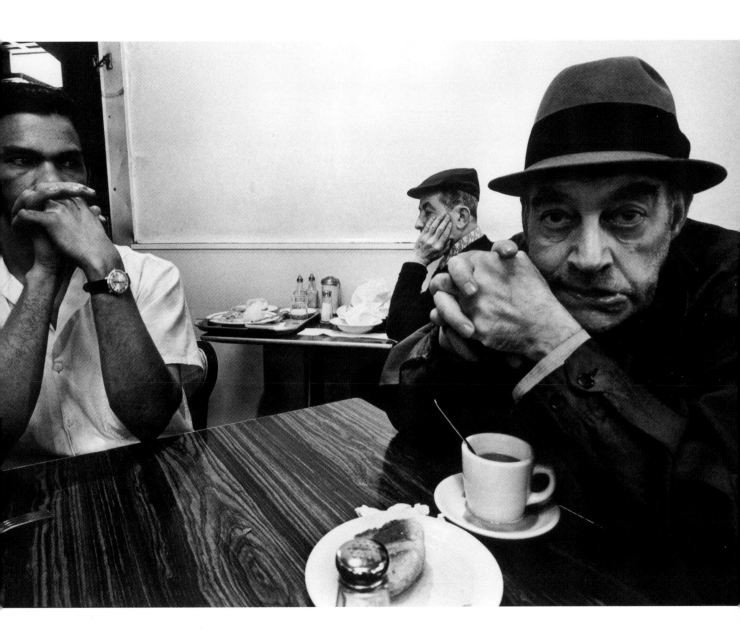

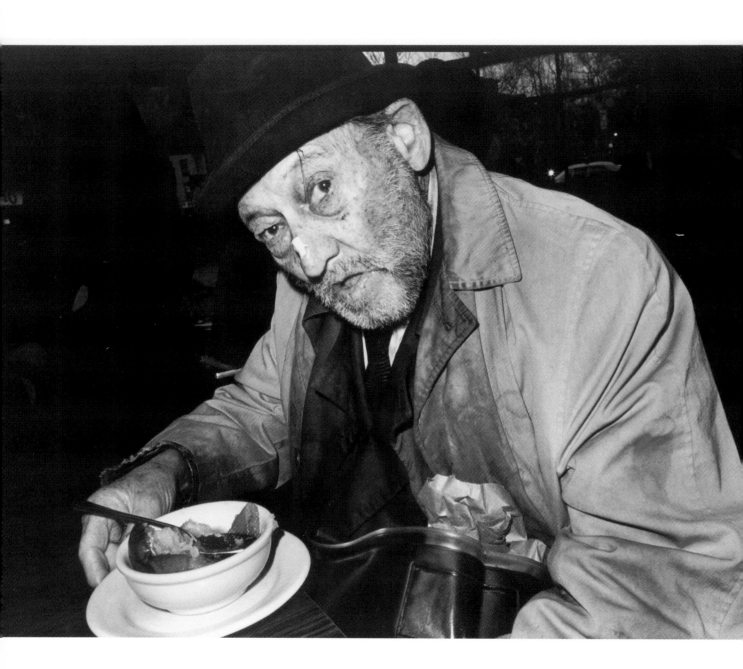

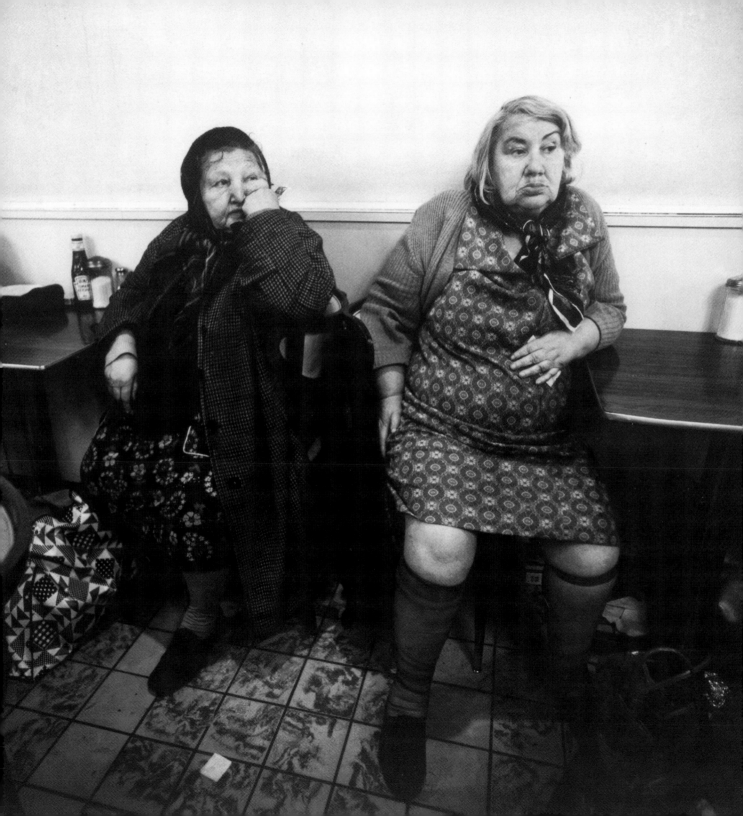

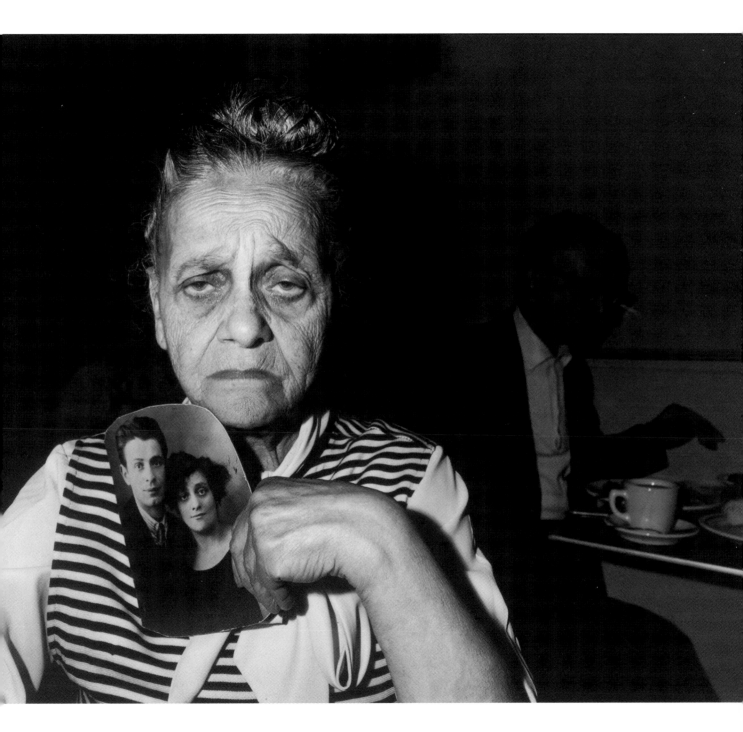

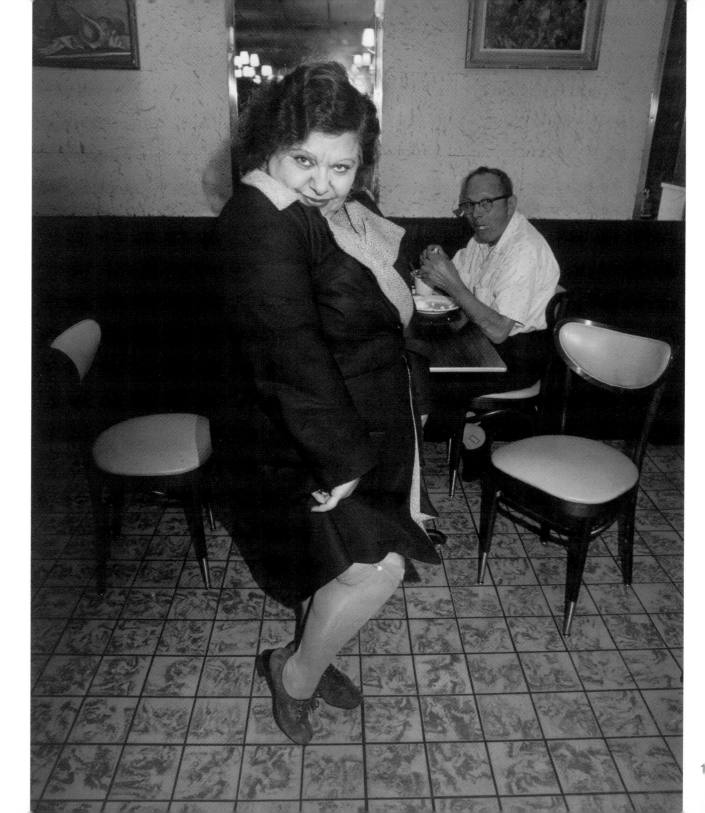

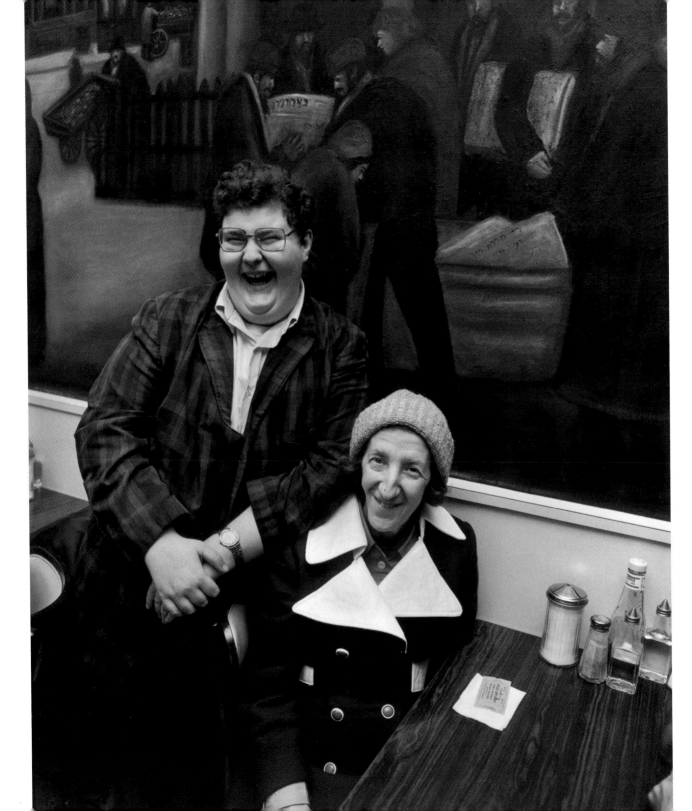

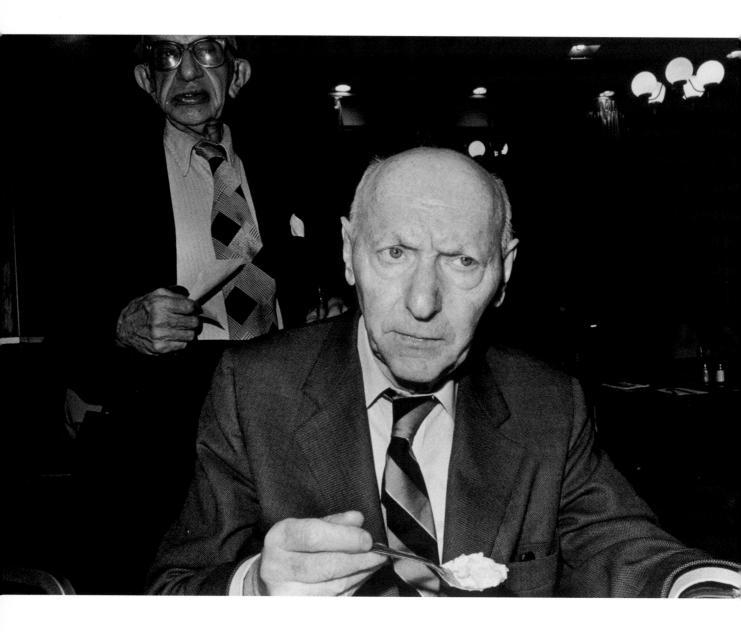

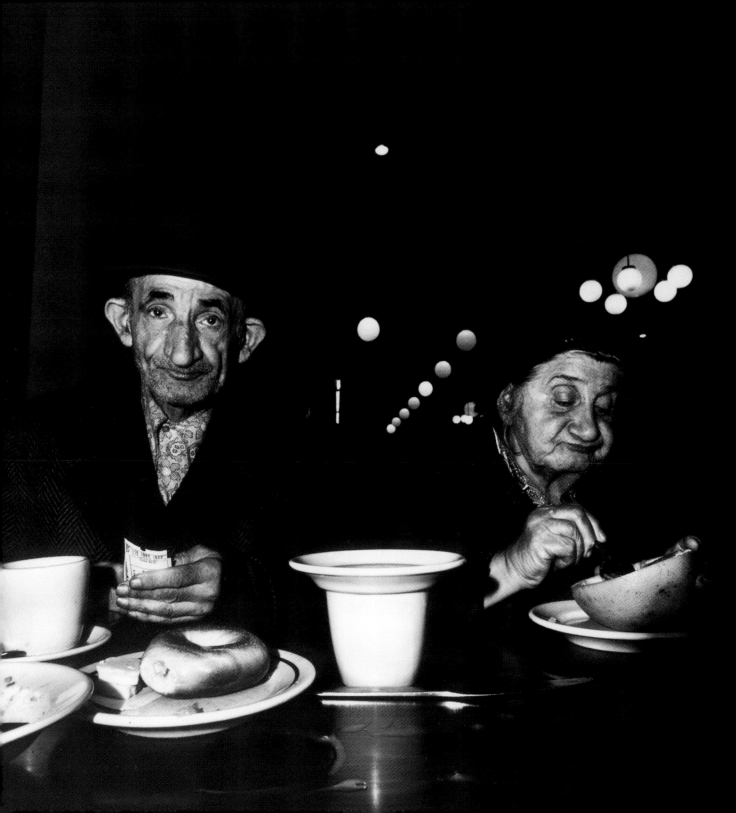

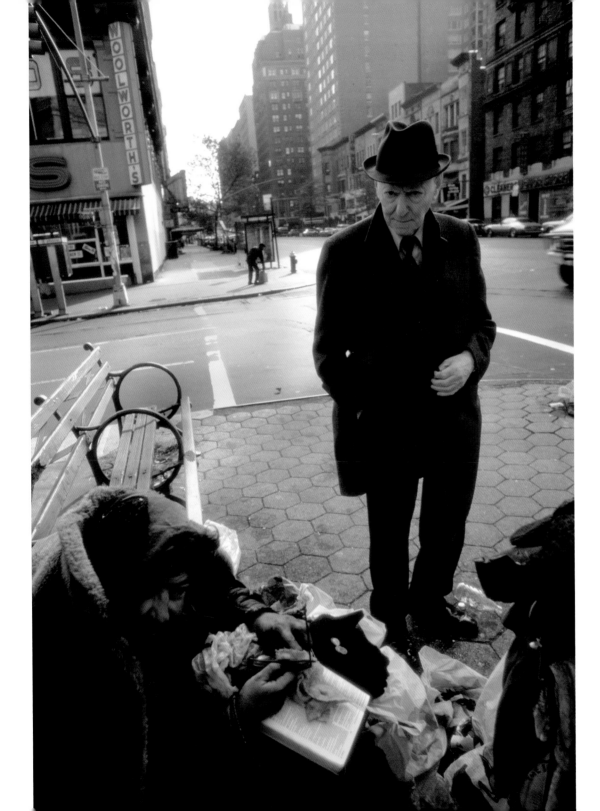

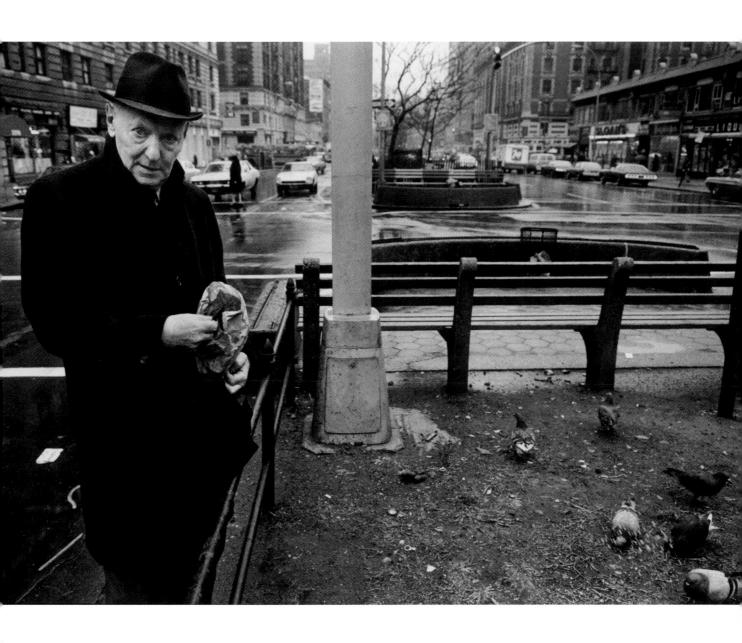

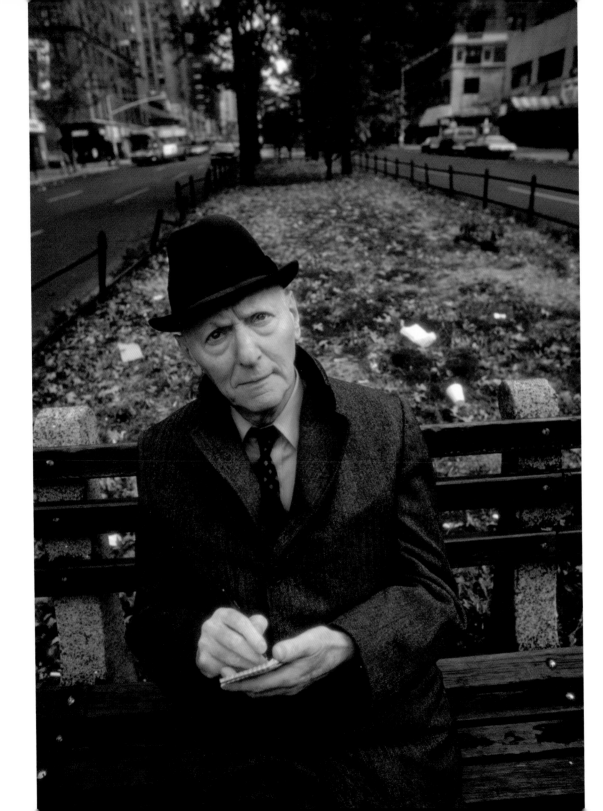

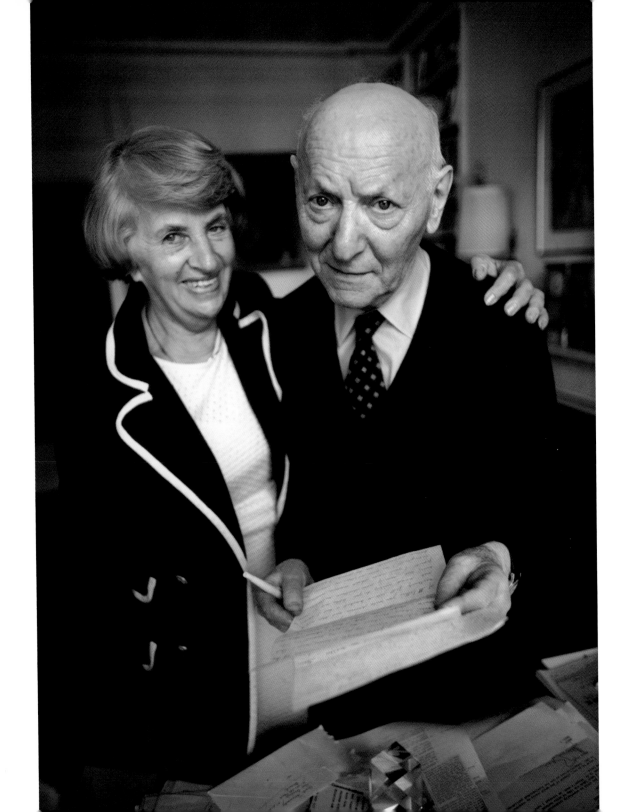

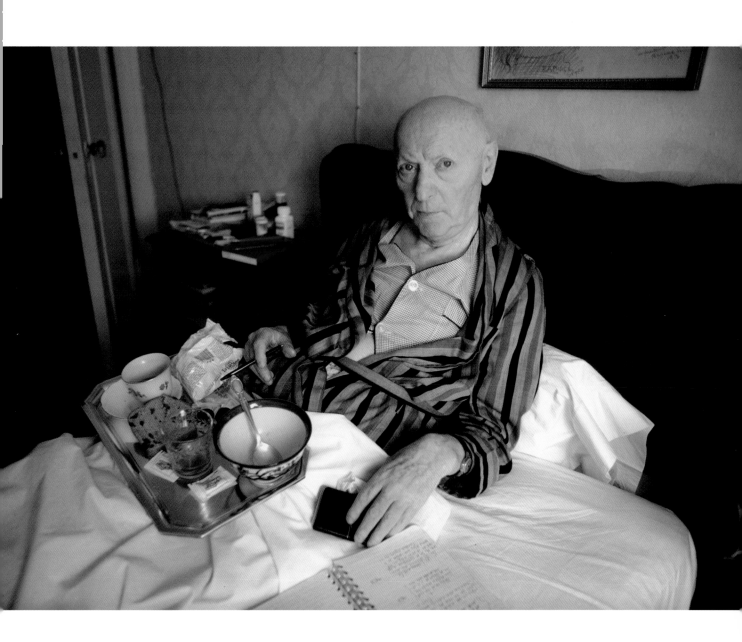

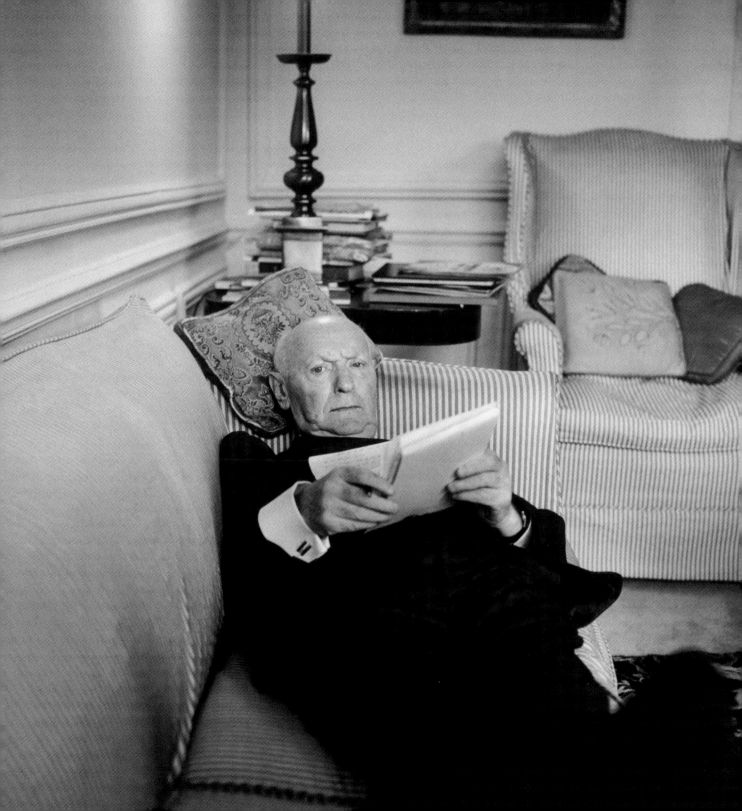

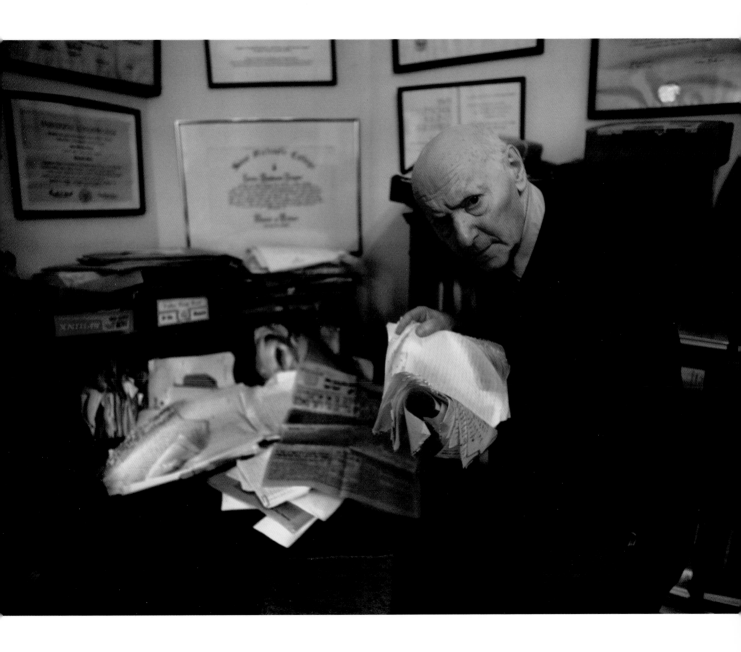

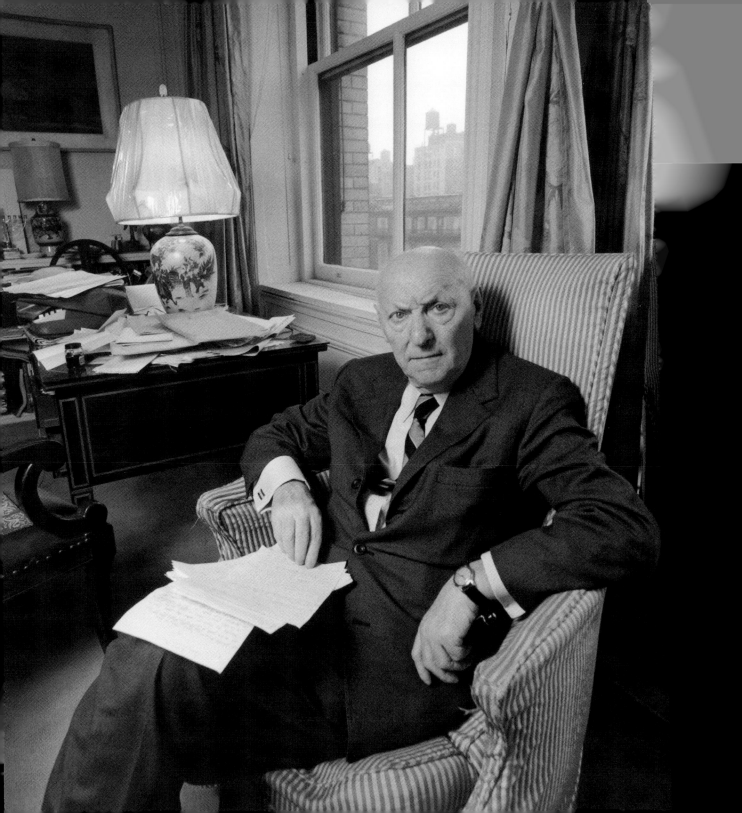

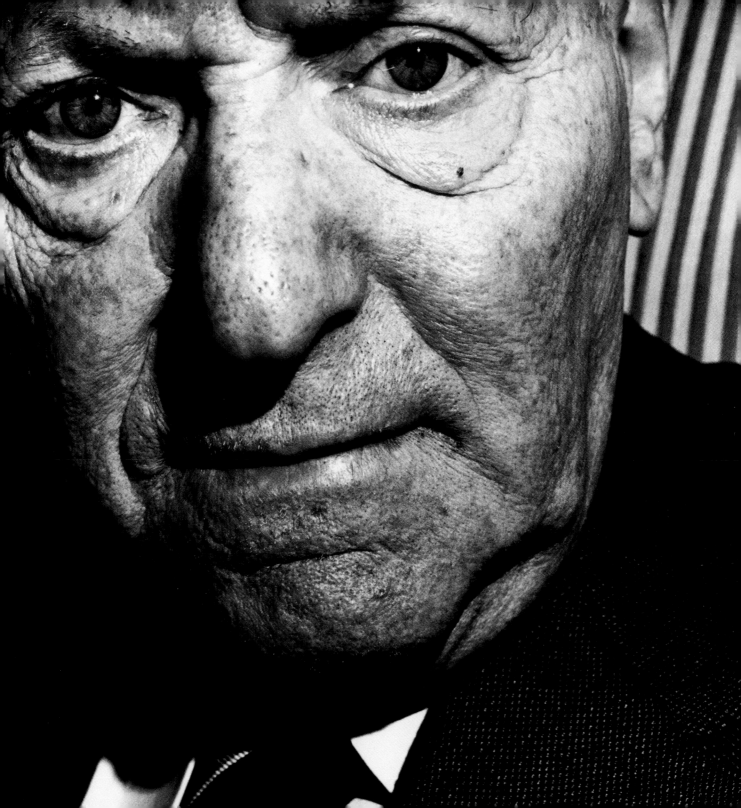

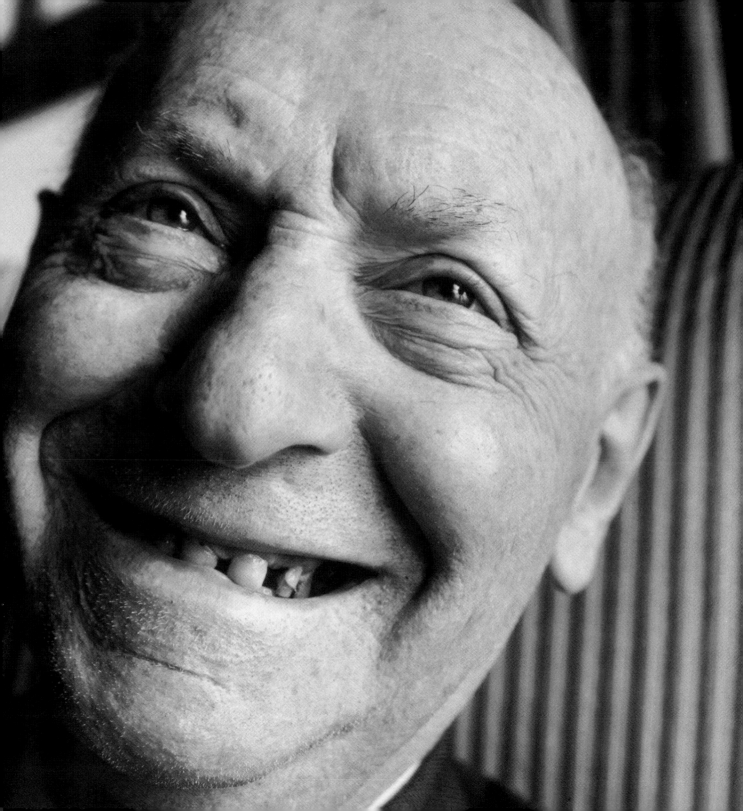

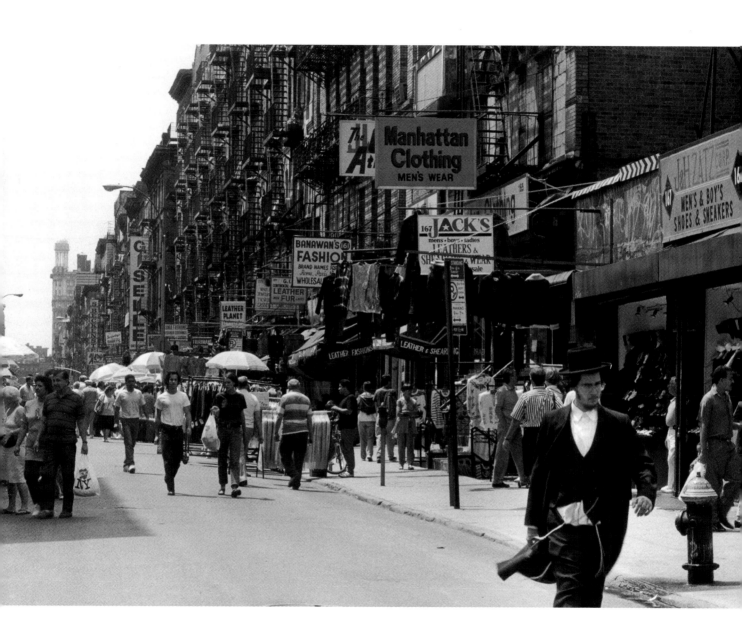

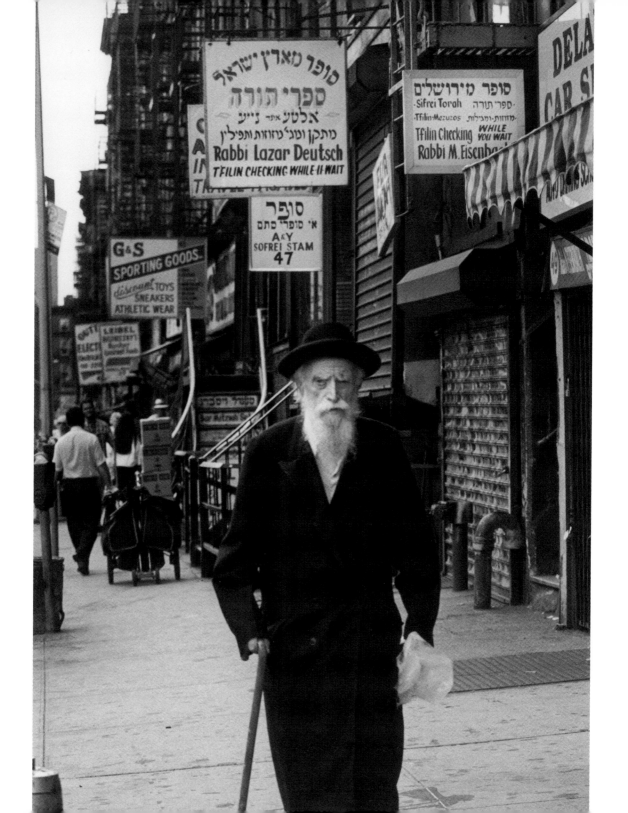

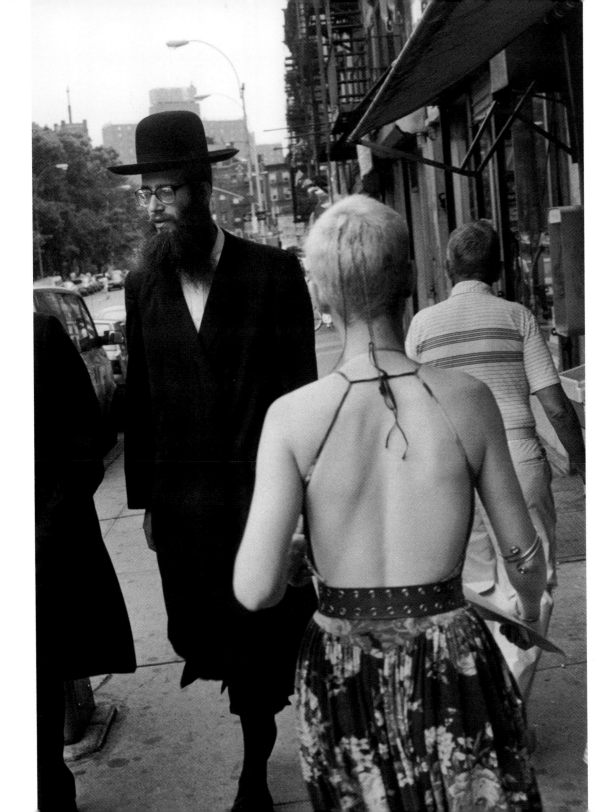

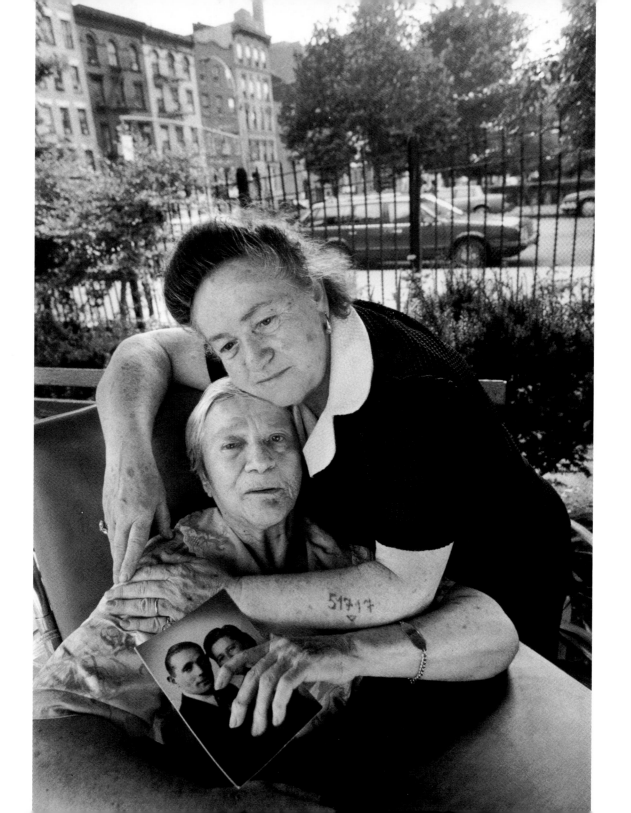

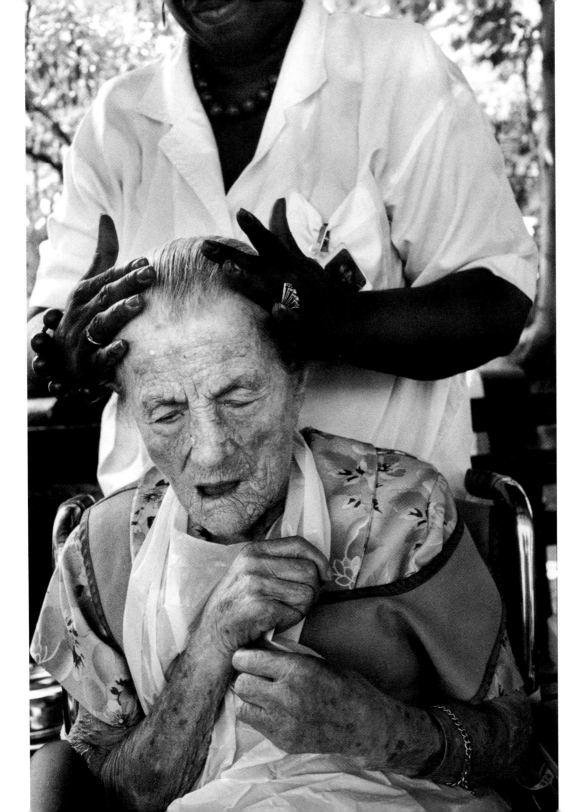

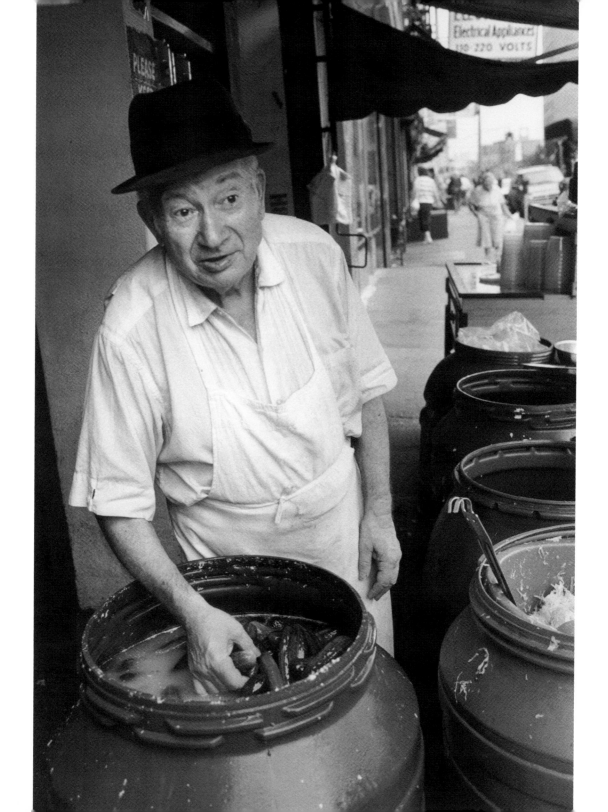

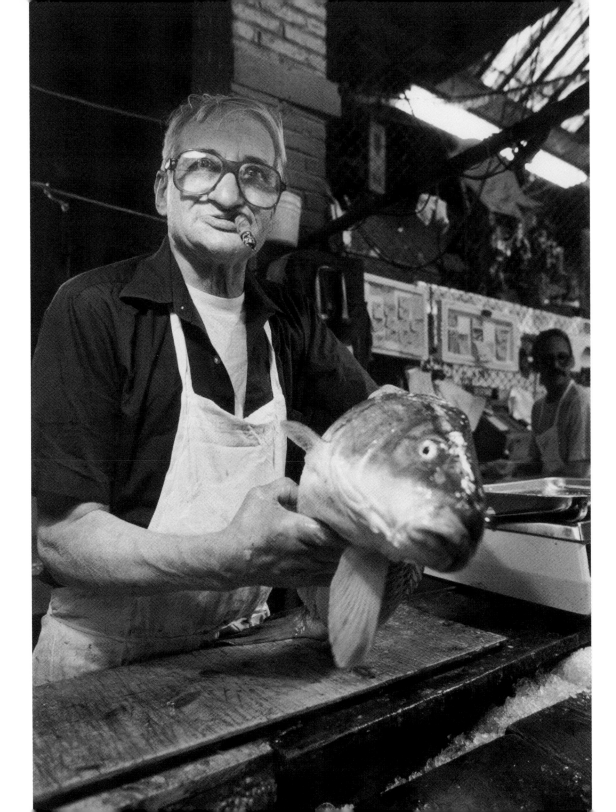

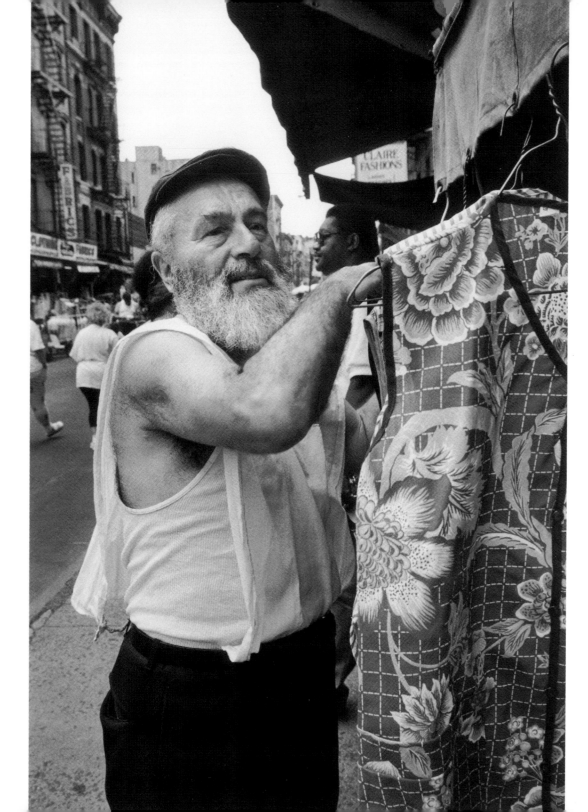

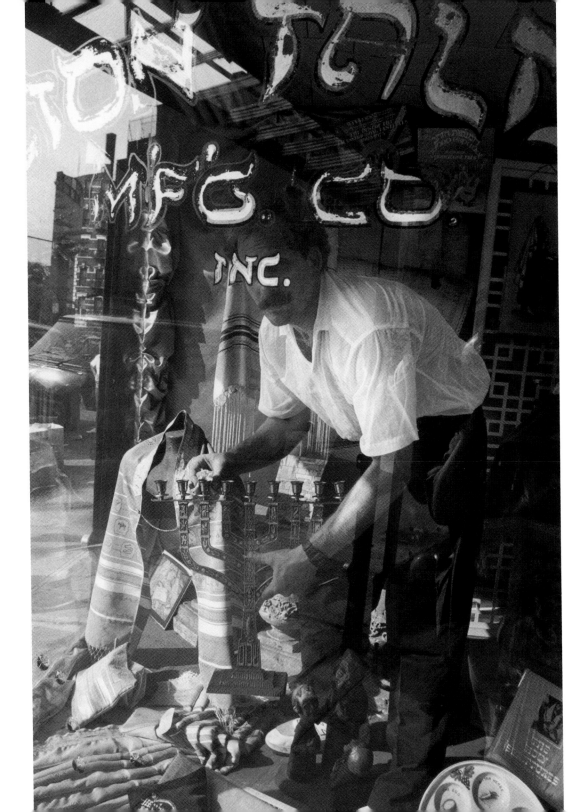

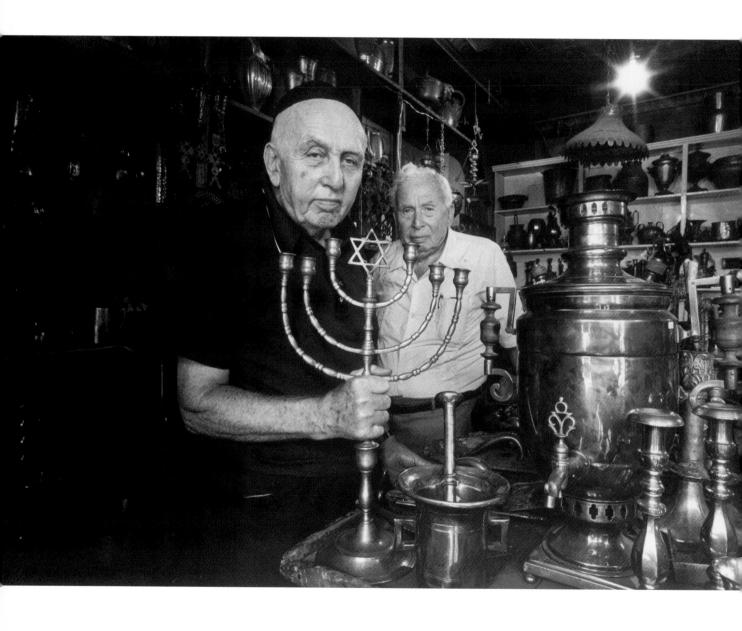

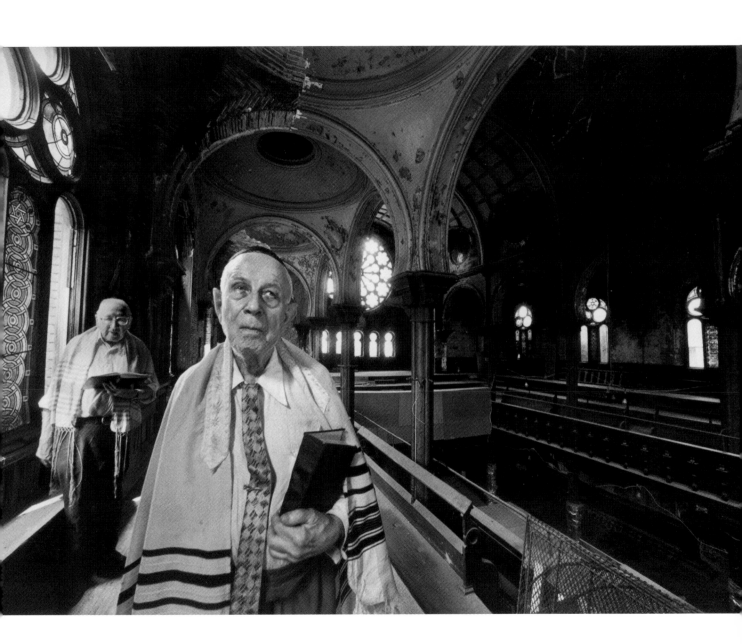

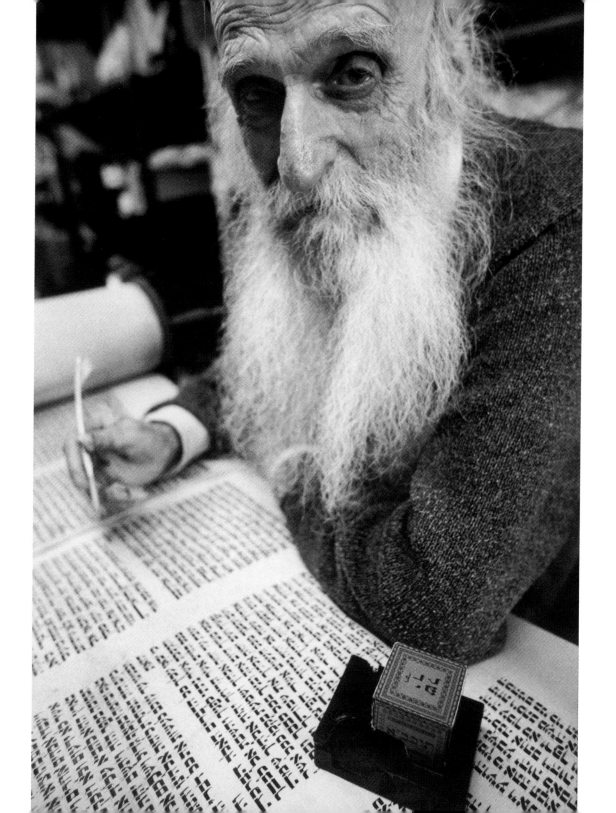

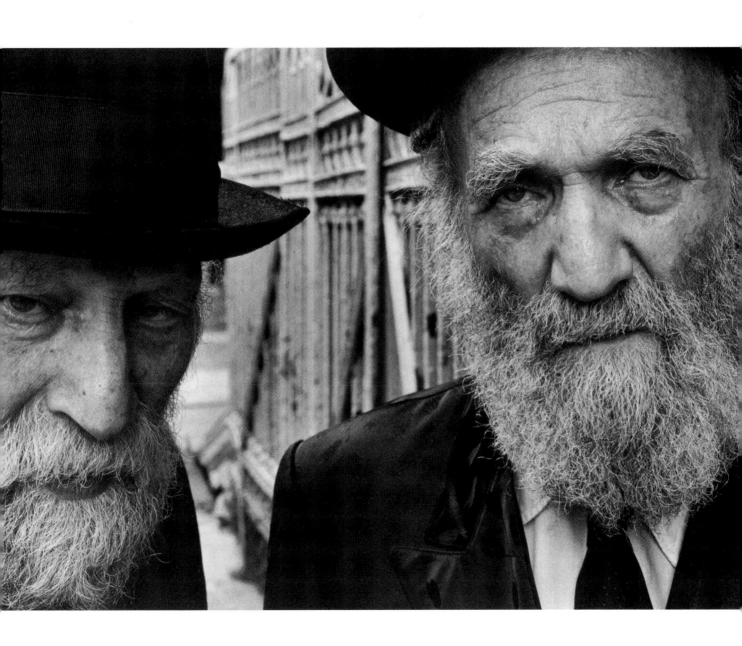

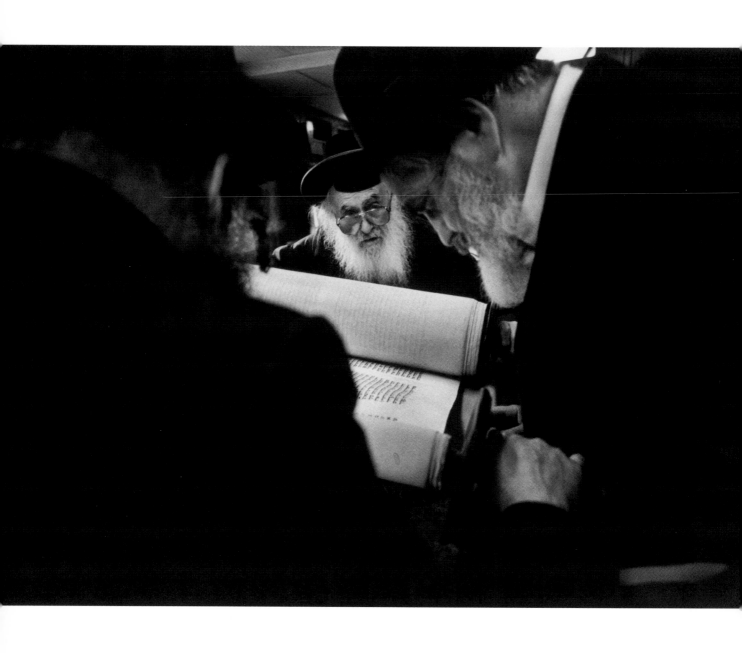

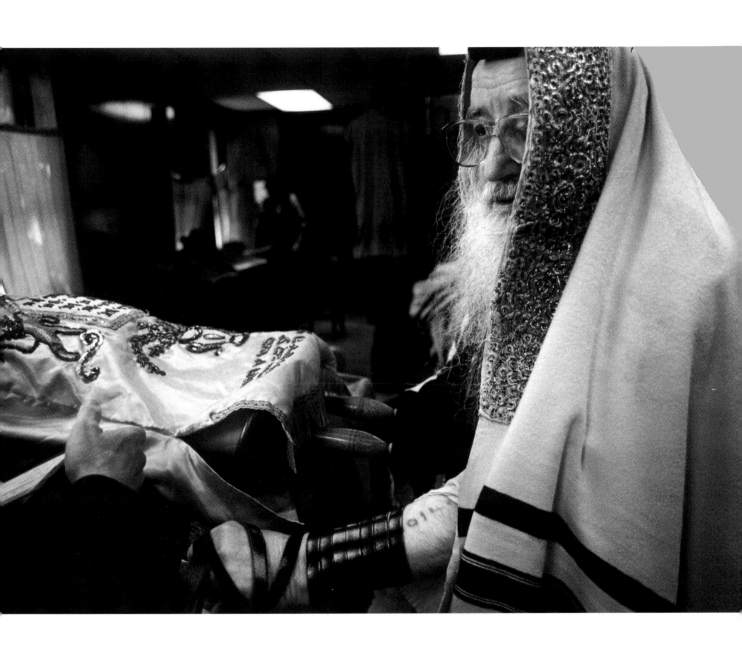

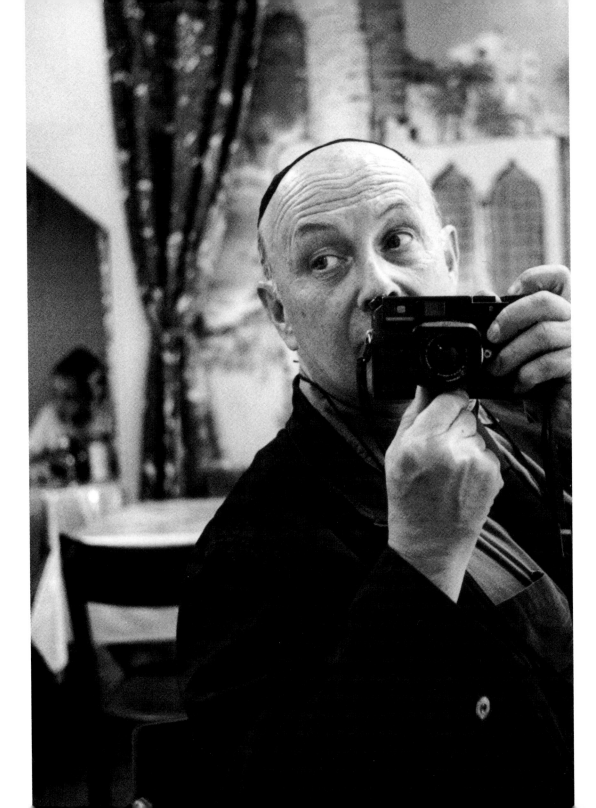

LIST OF ILLUSTRATIONS

Plate 1
Jewish schoolboy and girl with doll, 1957, gelatin silver print

Plate 2
Kosher butcher and baby carriage,1957, gelatin silver print

Plates 3 & 4
Isaac Bashevis Singer, introduction to the Garden Cafeteria portfolio [Plates 5-17], typescript, 1973

Plate 5 [cover, page 9]
Woman in front of the Garden Cafeteria, 1973, gelatin silver print

Plate 6
Two men sitting in front of a mural, 1973, gelatin silver print

Plate 7
Three men in in their own thoughts and memories, 1973, gelatin silver print

Plate 8
Three men and a woman sitting at tables, 1973, gelatin silver print

Plate 9
Man with a package, holding a meal ticket, 1973, gelatin silver print

Plate 10
Three men seated, 1973, gelatin silver print

Plate 11
Man with bowl, 1973, gelatin silver print

Plate 12
Two women seated, 1976, gelatin silver print

Plate 13
Mrs. Bessie Gakaubowicz, holding a photograph of her and her husband, taken before the war, 1973, gelatin silver print

Plate 14
Ada Hirsh, the tango-dancing assistant cashier, 1973, gelatin silver print

Plate 15
Florence Strauss, a seller of *bialys*, and her son Martin Lockit, 1973, gelatin silver print

Plate 16 [frontispiece]
Isaac Bashevis Singer eating rice pudding, 1975, gelatin silver print

Plate 17
Storekeepers from a candy store on Avenue B, 1973, gelatin silver print

Plate 18
Isaac Bashevis Singer and homeless woman on Broadway, 1978, Lambda c-print

Plate 19
Isaac Bashevis Singer feeding pigeons on Broadway, 1975, gelatin silver print

Plate 20
Isaac Bashevis Singer on Broadway sitting on a bench, 1978, Lambda c-print

Plate 21
Isaac Bashevis Singer and his wife Alma, 1978, Lambda c-print

Plate 22
Isaac Bashevis Singer in bed with his breakfast tray, 1978, Lambda c-print

Plate 23 [page 21]
Isaac Bashevis Singer reclining on a sofa, 1975, gelatin silver print

Plate 24
Isaac Bashevis Singer in his study, 1978, Lambda c-print

Plate 25
Isaac Bashevis Singer in a chair, 1975, gelatin silver print

Plate 26
Isaac Bashevis Singer in close-up, 1975, gelatin silver print

Plate 27 [flyleaf]
Isaac Bashevis Singer smiling, 1975, gelatin silver print

Plate 28 [inside cover]
Orchard Street, 1990, gelatin silver print

Plate 29
Essex Street with Yiddish shop signs, 1990, gelatin silver print

Plate 30
Essex Street, 1990, gelatin silver print

Plate 31
Sara Lermann (above) visits her sister Lola Posner at the Bialystok Nursing Home on East Broadway, 1990, gelatin silver print

Plate 32
An aid fixing an old woman's hair at the Bialystok Nursing Home on East Broadway, 1990, gelatin silver print

Plate 33
In front of the Essex Street Pickle Corp., also known as "Gus's Pickles," 1990, gelatin silver print

Plate 34
Hershy and a carp at the fish market on Essex Street, 1990, gelatin silver print

Plate 35
Street merchant, 1990, gelatin silver print

Plate 36
Steven Yaroslawitz in the window of his Judaica shop on Eldridge Street, 1990, gelatin silver print

Plate 37
The Kleinstein brothers in the antique brass store on Allan Street started by their grandfather, 1990, gelatin silver print

Plate 38
Interior of the Eldridge Street Synagogue with 90 year-old Küster Markowitz in the foreground, 1990, gelatin silver print

Plate 39
Rabbi A. M. Eisenbach, an importer, seller, and restorer of Torahs and old texts, on Essex Street, 1990, gelatin silver print

Plate 40
Two esteemed members of the community: Rabbi Moishe Singer (left) and his brother Rabbi Joseph Singer, 1990, gelatin silver print

Plate 41
Three rabbis in the "House of Sages" on East Broadway reading Torah, 1990, gelatin silver print

Plate 42
Rabbi in the "House of Sages" on East Broadway, 1990, gelatin silver print

Plate 43
Bruce Davidson self-portrait, 1990, gelatin silver print

TEXT ILLUSTRATIONS

Page 24
Roman Vishniac, A shopping street in the Nalewki, the heart of the Jewish quarter of Warsaw, 1936-39, gelatin silver print, copyright © Mara Vishniac Kohn, courtesy International Center of Photography

Page 25
Roman Vishniac, Rabbi Leibel Eisenberg and his *shames*, Lask, 1936-39, gelatin silver print, copyright © Mara Vishniac Kohn, courtesy International Center of Photography

Page 35
Emily Haas Davidson, Isaac Bashevis Singer, Bruce Davidson, 1972, gelatin silver print

Page 39
Bruce Davidson, Isaac Bashevis Singer, and Jack Wiener as "Mrs Pupko," 1972, gelatin silver print

Page 40
Emily Haas Davidson, Isaac Bashevis Singer, Bruce Davidson, and film crew, 1972, gelatin silver print

Page 49
Isaac Bashevis Singer and Jack Wiener as "Mrs Pupko," 1972, gelatin silver print

Pages 52, 54-57
Film stills from "Isaac Bashevis Singer's Nightmare and Mrs. Pupko's Beard," 1972

CONTRIBUTORS

Isaac Bashevis Singer (1904 - 1991), considered the most famous Yiddish writer of the twentieth century, produced fiction serialized in *The Forward* as well as political commentary, popular journalism, and advice columns under assumed names. Beginning with *The Family Moskat* (1950), his stories and novels were translated and published in English, bringing him to a wider audience in America and worldwide. His dozens of publications include *Satan in Goray* (1955), *Gimpel the Fool and Other Stories* (1957), *The Magician of Lublin* (1960) *The Spinoza of Market Street and Other Stories* (1961), *Enemies: A Love Story* (1972), *A Crown of Feathers and Other Stories* (1973), *Shosha* (1978), *Yentl the Yeshiva Boy* (1983), *Shadows on the Hudson* (1998), and also books for children and plays. Singer was awarded the Nobel Prize in Literature in 1978.

Bruce Davidson (b. 1933), the renowned documentary photographer, joined Magnum Photos in 1958. He was given a solo exhibition at the Museum of Modern Art in New York in 1963, which included *The Dwarf, Brooklyn Gang, The Freedom Rides,* and other Civil Rights era images supported by a Guggenheim Fellowship. In 1966, Davidson was awarded the first grant in photography from the National Endowment for the Arts and spent two years documenting one block in East Harlem. His books of photographs include the landmark 1959 study *Brooklyn Gang* (1998), *East 100th Street* (1970, reprinted 2003) *Time of Change, Civil Rights Photographs 1961-1965* (2002), *Subway* (1986, reprinted 2004).

Ilan Stavans is the Lewis-Sebring Professor of Latin American and Latino Culture at Amherst College. His books include the best-selling *The Hispanic Condition* (1995) and *On Borrowed Words: A Memoir of Language* (2001). He is also the editor of *The Oxford Book of Jewish Stories* (1998), *The Poetry of Pablo Neruda* (2003) and the three-volume set of *Isaac Bashevis Singer: Collected Stories* (2004). Routledge published *The Essential Ilan Stavans* in 2000 and the University of Wisconsin Press released *Ilan Stavans: Eight Conversations* by Neal Sokol in 2004. The recipient of numerous honors,

including an Emmy nomination, a Guggenheim Fellowship, the Latino Literature Prize and the Antonia Pantoja Award, his work has been translated into half a dozen languages.

Jill Meredith is the Director of the Mead Art Museum at Amherst College and curator of the exhibition, *Isaac Bashevis Singer and the Lower East Side: Photographs by Bruce Davidson.* Recently, she has curated exhibitions of documentary photographs by Steve Schapiro and Phyllis Galembo.

Gabriele Werffeli was the editor at *Du* magazine in Switzerland who commissioned Bruce Davidson to return to the Lower East Side in 1990 to photograph the remnants of the life Isaac Bashevis Singer portrayed in his stories and novels.

ACKNOWLEDGMENTS

Bruce Davidson wishes to thank Jill Meredith who conceptualized this body of work, as exhibition curator, and edited this volume. Her energy and intelligence made it all possible. He is grateful to Ilan Stavans for orchestrating the yearlong Singer centenary activities and for bringing this body of work to a wider audience. In addition, Donna M. Abelli's innovative design, attention to detail, and oversight during the printing of this catalogue is much appreciated. He thanks, also, Magnum Photos and Howard Greenberg Gallery for their support.

Ilan Stavans extends his gratitude to Max Rudin of the Library of America, Robert Lescher of Lescher and Lescher, Harold Augenbraum of the Mercantile Library of New York, Nora Gerard and Nancy Sherman of the National Yiddish Book Center, and Robert Mandel of the University of Wisconsin Press for their ongoing support. He thanks the National Endowment for the Humanities for its generous sponsorship of the Isaac Bashevis Singer centennial celebration.

Jill Meredith conveys deep appreciation to co-contributors, Bruce Davidson, Ilan Stavans, and Gabriele Werffeli, and graphic designer, Donna M. Abelli, for their insights and enthusiasm throughout the project. She extends her gratitude to Carol Solomon Kiefer for proofreading and to Sebastian Renfield for copy-editing and digital image assistance. She wishes to thank Robert Mandel and his staff at the University of Wisconsin Press for their collaborative efforts.

Sara Macel, studio manager of Bruce Davidson Photography, Magnum Photos, provided logistical assistance to us all and Emily Haas Davidson contributed her invaluable research on the Lower East Side and its inhabitants. Mara Vishniac Kohn and Cynthia Young at the International Center of Photography made Roman Vishniac's photographs available. And special thanks are extended to Emily and Bruce Davidson, who opened their hearts and home to us.

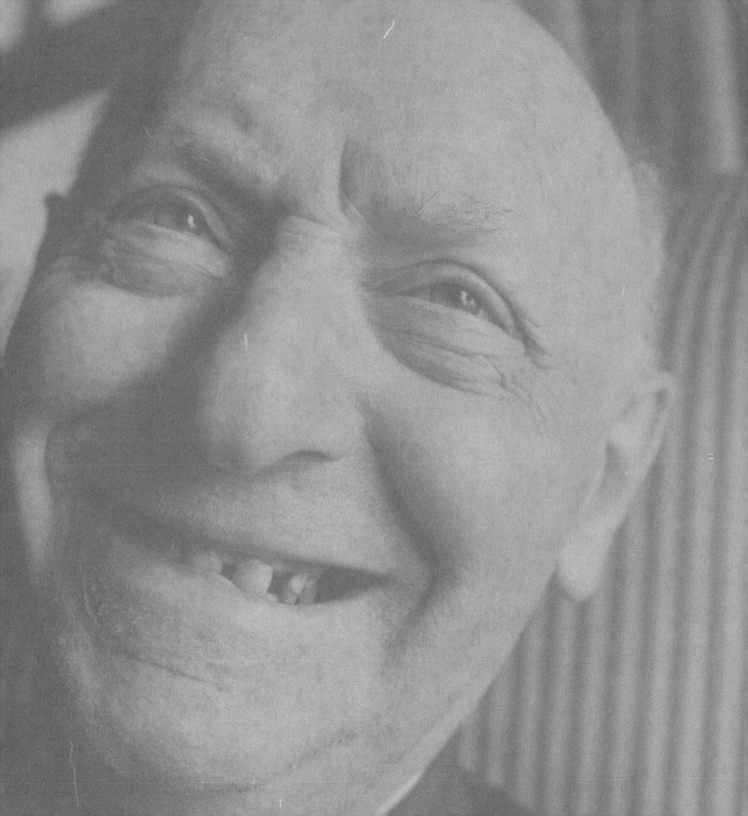